IMAGES
of America

JEROME

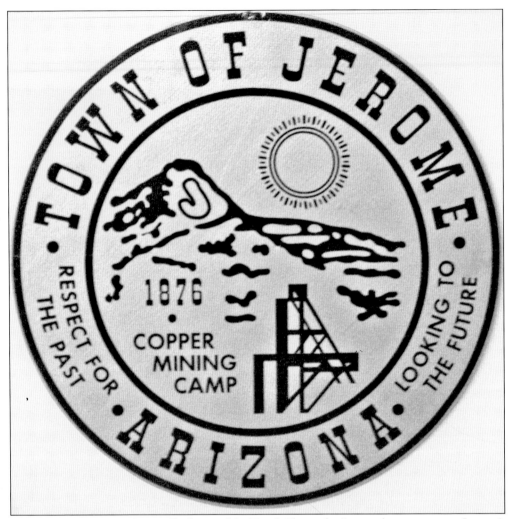

JEROME TOWN LOGO. Originally designed by Frank Ebert, the Jerome logo represents Jerome's strong copper-mining origin, with the year of the first recorded copper claims, an ore headframe, the J painted above town on Cleopatra Hill, clear sunshine, and views to the open-pit mine with the inscriptions "Respect for the past" and "Looking to the future." (Photograph by author.)

ON THE COVER: This 1910 photograph of a burro pack train was taken on First Avenue with the Bartlett Hotel on the right, the upper town park bandstand behind, and Company Hill in the background. The entire block of buildings on the left was destroyed in a tremendous mine blast below. This was reportedly the same blast that caused the sliding jail to slide across the street to its present resting place. Apparently there was a particularly monstrous explosive charge of 260,000 pounds (equivalent to six freight car loads) that may have caused these buildings to crumble, the jail to slide, and windows to rattle throughout the Verde Valley. (Courtesy Jerome Historical Society.)

IMAGES of America

JEROME

Midge Steuber and
the Jerome Historical Society Archives

ARCADIA
PUBLISHING

Copyright © 2008 by Midge Steuber and the Jerome Historical Society Archives
ISBN 978-0-7385-5882-0

Published by Arcadia Publishing
Charleston, South Carolina

Printed in the United States of America

Library of Congress Catalog Card Number: 2008926270

For all general information contact Arcadia Publishing at:
Telephone 843-853-2070
Fax 843-853-0044
E-mail sales@arcadiapublishing.com
For customer service and orders:
Toll-Free 1-888-313-2665

Visit us on the Internet at www.arcadiapublishing.com

We've walked through the fire together,
Stood in silent awe and reverence at the beauty of nature,
Climbed some pretty tall mountains . . .
And dissolved into tears of hysterical laughter over the antics of
Clem Kadiddlehopper!
You have given me an understanding of the true meaning of life.

I dedicate this book to my son, Lucas Carl Steuber, my most profound
and cherished teacher. I love you.

Contents

Acknowledgments		6
Introduction		7
Timeline		10
1.	Strength of Spirit	11
2.	Hard Work	29
3.	Kick Up Your Heels	63
4.	Equally Hard Mountain	81
5.	Hearts of Service	95
6.	Jerome Historical Society and Mine Museum	103
7.	Jerome State Historic Park	123
Bibliography		127

ACKNOWLEDGMENTS

Enchanted with the history and character of Jerome since my first visit, I gained a deep love for Jerome's colorful story, a love that has only grown over the years.

I would like to acknowledge my original neighbors on Dundee who are in many ways responsible for igniting my Jerome passion by telling hours and hours of their stories: Gary Felix and Richard Johnson.

I have deep gratitude for the Jerome Historical Society (JHS), both to the founders' vision and the current staff for welcoming my volunteer efforts and allowing me to immerse myself in their archives: Christine Barag, Jay Kinsella, Rochelle Garcia, Ron Roope, Shirley R. Pogany, and Annie Mae Kelly. Unless otherwise noted, all the photographic images herein are credited to the Jerome Historical Society.

Next I will thank the current residents of Jerome for their warm hearts; the first four people I met in Jerome told me, "Jerome is not a town but a family, welcome home!" Those words were immediately followed by an overwhelming gentle tenderness for Jerome. I found myself relaxing into a sweet sense of homecoming, as if I were surrounded by kindred spirits and old friends. Jerome has consistently proven to be a place of heart made of strong, spirited people. I have heard numerous priceless Jerome stories, for which I wholeheartedly thank the following: Jerry Vojnic, Christine Barag, James and Vivianne Poe, Jay Kinsella, Greg Driver, Blue Bolter, Terry Molloy, Al Palmeri, Gil Robinson, Richard Spudich, Gary Shapiro, Tom Pitts, Mary Wells, Peggy Tovrea, Walter Johnson, Manuel Sanchez, and Kathleen Jarvis. I ask for forgiveness for my unintentional oversight if I have forgotten anyone.

And a special thanks goes out to Nora Graf of the Jerome State Historic Park for her help with my research on the Douglas family and properties.

I have a huge amount of gratitude and appreciation for my friend Kevin Duebler, whose endless encouragement and unfailing emotional support and enthusiasm for this project helped immensely to keep it moving along to completion. Thank you, Kevin. You deserve a bucket full of gold stars!

My final thanks go to my editor, Jared Jackson, and to Scott Davis for their can-do attitudes and priceless technical help from Scott.

Most of the information in this book about the history of Jerome was synthesized from the books and pamphlets listed in the bibliography. I have made every effort to be accurate in my retelling of stories; however, I would like to apologize now for any errors or omissions.

INTRODUCTION

The story of Jerome is one of strong, spirited people. There were two main mines and two main mine owners: William Andrews Clark (1839–1925), the Copper King, owner of the United Verde Copper Company (UVCC); and James Stuart Douglas (1867–1949), "Rawhide" Jimmy, the Copper Prince, owner of the Little Daisy and United Verde Extension.

The lifetime accomplishments of William Andrews Clark are staggering. Herbert V. Young writes in *Ghosts of Cleopatra Hill*:

> Before he was fifty he was a multimillionaire and the owner of United Verde. During the sixty years of his active pursuit of wealth he developed and acquired enterprises which made fortunes in commerce, banking, lumbering, manufacturing, public utilities, real estate, railroading, stock raising, sugar refining and mining—especially mining. He owned many mines in his lifetime; six of them returned millions. Chief among the mines, and his favorite, was the United Verde in Jerome.

Clark was elected U.S. senator from Montana from 1901 to 1907. It is reported that Clark was generous to his towns and employees, providing high salaries and many social and cultural amenities. The ruins of his elegant and massive Montana Hotel that he built for his miners can still be easily seen on Cleopatra Hill, also known as Company Hill. It is also reported that Clark was instrumental in having a territorial law passed instituting the eight-hour workday in the mines of Arizona.

Clark was also an art collector, buying and selling what pleased him and letting cost be damned. His collection can be seen in its entirety at the Corcoran Museum in Washington, D.C. With this art heritage, it is very fitting that Jerome has evolved into a well-known and respected artists' community.

Clark County, Nevada, is named after Clark, who established the railroad that linked Los Angeles and Salt Lake City. Las Vegas was founded in 1905 after Clark's railroad, which made stops there, purchased land for a town site and sold lots by auction, creating the downtown.

Readers can now begin to have an idea of the incredible strength and enterprising spirit of Clark. Clark was an incredible mover and shaker. When fires were burning in his UVCC mine, he moved the mountain to get at the remaining high-grade ore: he relocated the smelter, built three railroads, a huge tunnel, and a town, and took down the mountain, creating the open-pit mine. In 1894, the United Verde Copper Company smelter poured 11 million pounds of copper, which contained 7 million ounces of silver and $1.5 million in gold. This reportedly began the legend that the silver and gold in the UVCC ores paid all operating expenses and left returns from copper pure profit.

By the time the United Verde mine had been worked out in 1953, it had produced two and a half billion pounds of copper, 50 million ounces of silver, a million ounces of gold, and many millions of pounds of zinc, with a gross value in excess of $1 billion. The United Verde was the

largest mine; however, as the accompanying 1926 map of Jerome's Mining District shows, there were many more mines in the mountains and valleys around Jerome.

Herbert V. Young writes in *The Ghosts of Cleopatra Hill*:

> Some estimators have valued W. A. Clark's peak holdings at a value of between 300 and 500 million dollars. He was classed by Senator Robert La Follette as among the hundred capitalists who ruled America, and Bernard Baruch once named him as one of America's richest twelve.

New ore discoveries in 1902 reportedly made Clark the richest man in the world, surpassing the Astors, Vanderbilts, Rockefellers, Goulds, and Rothschilds. Jerome began to be known as "The Billion Dollar Copper Camp."

The story of Clark was extraordinary, but even more extraordinary is the incredible intergenerational mine waltz the Douglas family did with Clark. This is the same Douglas after whom Douglas, Arizona, is named. In 1881, Dr. James Douglas was brought to Jerome to investigate the worthiness of the mines here for purchase. Douglas declared the ore to be of high grade but advised his clients not to buy because of transportation difficulties. At that time, the closest railroad station was in Pueblo, Colorado. This was during the practically roadless days of the West, of horses, mules, and burros; Jerome was absolutely without a road. When the mine came up for sale again in 1887, Douglas advised Phelps Dodge to take an option, but the deal fell through, and Clark became the proud owner instead. Years after Clark bought UVCC, a deputy U.S. mineral surveyor named J. J. Fischer studied the mining claims of Jerome and noticed an overlooked spot that he thought looked promising. Fischer sank a shaft and called it the Little Daisy. James Stuart Douglas, also known as "Rawhide" Jimmy, the Crown Prince of Copper, and the son of Dr. James Douglas, joined Fischer in this claim in 1912. Douglas changed the name to the United Verde Extension (UVX), and it was a bonanza. The Little Daisy of the UVX yielded $52 million in dividends before shutdown in 1937.

On April 19, 1967, Secretary of the Interior Stewart L. Udall presented Jerome with the commemorative plaque that designated the Jerome Historic District as a Registered National Historic Landmark and placed it on the stone wall across from the Mine Museum on Main Street.

My idea for working on a Jerome book project came from realizing that Jerome had a huge number of visitors and no real visual guide to give them a historical sense of what they were seeing and experiencing. I wanted to be sure Jerome's visitors came away with a sense of what it was like in Jerome's heyday and of the town's vibrant mining history. I felt it also important to share some of the past and present stories I have learned or experienced since living here, which are so unique to Jerome. These stories help explain the heart and soul of Jerome, her magic, and why Jerome is so much more than just another small mining town. Indeed, there used to be a sign entering Jerome that read, "The Most Unique City In America." In an article in the *New York Sun* on February 5, 1903, Jerome was called the "Wickedest Town in America." Jerome has also been known as the "Largest Ghost City in America," the "City of Romantic Ruins," "Arizona's Sodom and Gomorrah," and on T-shirts currently sold at the Cheers T-shirt store in uptown Jerome, "A biker town with an artist's problem!" This is playful; we love the artists and the bikers. All are welcome here!

While working on this project, I have asked a number of locals for the one word or phrase that best describes Jerome for them. The first response I heard was from James and Vivianne Poe, the owners of Cheers T-shirts, who said, "A sense of community." Another response, this one from former three-time Jerome mayor Jay Kinsella, was "blessed." A response from longtime resident and owner of Paul and Jerry's saloon Jerry Vojnic was "family." All are wonderful representations of what the locals feel about our town—fortunate to be living here and with a real sweet sense of close community.

Jerome people look after each other. There is a children's Christmas party and potluck that reportedly goes way back to the time of "Rawhide" Jimmy Douglas and still continues today.

We have community potluck Thanksgiving and Christmas dinners. Halloween is celebrated all over town with various "Spook Weekend" festivities, including a not-to-be-missed masquerade dance put on by the Jerome Volunteer Fire Department. Visitors come to Jerome from all over the Southwest on Spook Weekend—what a perfect place to be on Halloween in this vibrant, enchanting, and colorful ghost town that never died. Spook Weekend is also the time of the annual informal homecoming, where hundreds of ex-Jeromites return to Jerome to share fellowship and memories. There is an additional homecoming that happens in April for past Jerome High Schools students. These strong homecoming turnouts repeatedly demonstrate the great love and magnetic pull Jerome has on her residents—past and present. My hope is that this book project will give the Jerome visitor a strong visual sense of her historic past as well as the enchanting magic of the community.

There are reportedly 88 miles of shafts and tunnels under the town. There are four geological faults crisscrossing under the Jerome area: the Verde fault, Haynes fault, Hull fault, and Florencia fault. Jerome had a reported population of 15,000 people in her heyday and less than 50 at her low. Jerome was the fourth largest city in Arizona at one time. Four Jerome lawmen were killed in the line of duty from 1891 to 1933. There were at least two Jerome brokerage houses selling shares of mining stock, two opera houses, three bowling alleys, gambling halls, over 86 saloons from 1900 to 1916, and many "ladies of the night." This includes a famous one who happens to share the author's name of Midge. Apparently Midge or "Midgie" was a "soiled dove" who worked for Belgian Jennie Bauter. It is reported that when Midgie was "busy," Jennie would give the waiting men more whisky until Midgie could "accommodate" them: another example of Jerome's fine hospitality and sense of looking after each other!

Enjoy. We welcome you to Jerome and invite you to meet our family of colorful, strong, spirited community members—past and present. There are many stories reported in here; however, they are only a small fraction of the incredible stories Jerome has to offer.

Timeline

1100s	Ancestral Puebloans mined the blue/green copper for pigments.
1583	Antonio de Espejo, Spanish conquistador, gold hunter, and the first European to explore the mine, was reportedly brought by the Hopis.
1598	Farfan de los Godos, Spanish gold hunter, explored the mine.
1865	Al Sieber, Gen. George Crook's scout, staked the first, unrecorded copper claim.
1876	Angus McKinnon and Morris A. Ruffner (Wade Hampton and Eureka mines) filed copper claims.
1882	The growing copper camp got a name: Jerome. Investment capital was secured from Paulina Jerome of New York City. Eugene Jerome was a cousin of Jennie Jerome, Sir Winston Churchill's mother.
1882	Jake and Bill Mingus established a sawmill on their mountain, later called Mingus Mountain.
1882	United Verde Copper Company was organized.
1883	The first Jerome Post Office was established.
1884	The first schoolhouse was built in Jerome.
1888	February 14, Valentines Day. W. A. Clark took over United Verde Copper Company operations—one sweet deal.
1889	Jerome Public Library was founded.
1893	William A. Clark's United Verde and Pacific narrow-gauge railroad reached Jerome—connecting it with Ash Fork, Prescott, and Phoenix. Jerome boomed.
1894	The first of four big fires that almost destroyed town (1894, 1897, 1898, and 1899).
1899	The Town of Jerome was incorporated. (Jerome is older than the state of Arizona.)
1899	Telephone came to Jerome.
1900	The Montana Hotel was built (It burned and was blasted down in 1915).
1912	February 14, Valentine's Day. Arizona gained statehood.
1915	"Rawhide" Jimmy Douglas struck rich ore (United Verde Extension).
1916	Douglas Mansion was built (now Jerome State Historic Park).
1918	Little Daisy Hotel was built by the United Verde Extension Mining Company to serve as a boardinghouse for its miners. It closed in 1938 when UVX closed.
1918	The Spanish influenza pandemic arrived in Jerome.
1920	Women of Jerome won the right to vote.
1923	Jerome High School opened on the lower hogback.
1929	Jerome's population was reportedly 15,000. This was the year of the stock market crash, which signaled the Great Depression. The price of copper plummeted.
1932	Jerome's population fell to 4,748. Many of the miners had scattered to WPA jobs.
1933	Dynky Lynx miniature golf course opened in upper town park (approximately).
1935	Phelps Dodge bought United Verde for $20.8 million.
1938	UVX (Little Daisy) closed down.
1940	The Powderbox Church was finished (also known as the Mexican Methodist Church). It was built out of scrap wood, metal, and stucco. The material, mostly discarded dynamite boxes, was gathered and lovingly prepared by a devoted congregation.
1953	Phelps Dodge closed mining operations; Jerome Historical Society was founded.
1955	The population was less than 100.
1962	Douglas sons deeded Douglas Mansion to Arizona State Parks in memory of their father.
1967	Jerome was designated a National Historic Landmark.
1974	Jerome was awarded a bicentennial flag and plaque—designated a bicentennial town.
1976	100th birthday of the Town of Jerome.
1999	100th anniversary of the incorporation of the Town of Jerome.

One

STRENGTH OF SPIRIT

Jerome had a number of strong characters in addition to the powerhouse dynamos of the two main mine owners, Sen. W. A. Clark and Rawhide Jimmy Douglas.

Jerome had its own thriving "tenderloin district." Jennie Bauter was Jerome's most notorious madam, operating a large "crib" house situated on Main Street that was hard to ignore. There is a story told that when Jerome was burning, Jennie offered free passes for life to the firemen to protect her building—the building survived and still stands on Main Street today.

One can see many similarities between the television show *Gunsmoke* and the "Miss Kitty" who ran a hotel in a rugged Western town and Jerome's own Miss Kitty Christian Boyd. When miner John Boyd was killed in the mine, his wife, Kitty, took in boarders to get by and then built the brick Boyd Hotel that still stands on Main Street. It is reported that in 1899, Kitty Boyd was the fourth largest landowner in Jerome.

Edith Whitaker holds the distinction of being one of Jerome's most maverick women because she enjoyed working on and riding her own motorcycle and writing explosive exposés as the editor of the *Jerome Sun* newspaper. Edith is another of Jerome's vintage personalities who may have "spun a different way" for the times and would fit nicely in today's Jerome. If there is a Jerome theme or character, it could well be summed up as a fiercely independent community that is outspoken, marches to a different drummer, and holds a can-do, never-say-die attitude.

Dr. Charles W. Woods was appointed chief surgeon of the United Verde Copper Company after a most unusual medical training, described by Russell Wahmann in *Narrow Gauge to Jerome, The United Verde and Pacific Railway*:

> Charles W. Woods first worked as a laborer building the railroad in 1894. He came to the attention of H. J. Allen of the United Verde Copper Company when a construction worker had his leg crushed. . . . Apparently Woods had worked for a Doctor in New Orleans as a stable boy and driver and would occasionally assist the Doctor. He was a man of color and knew the south held little prospects for him. . . . Allen succeeded in having Woods granted a license to practice medicine and had him transferred to Jerome as the copper company Doctor and the railway's physician.

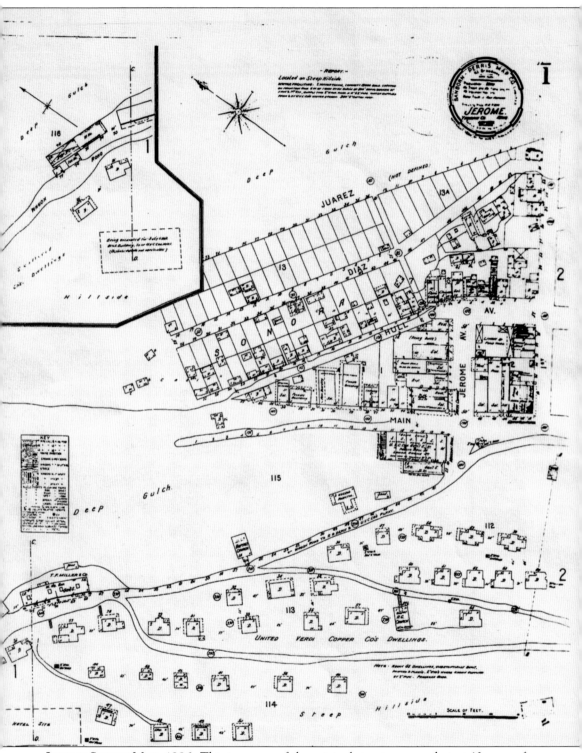

JEROME STREET MAP, 1886. This is a copy of the original street map made just 10 years after the first recorded claims were made in the Jerome mining camp. Several of these roads no longer

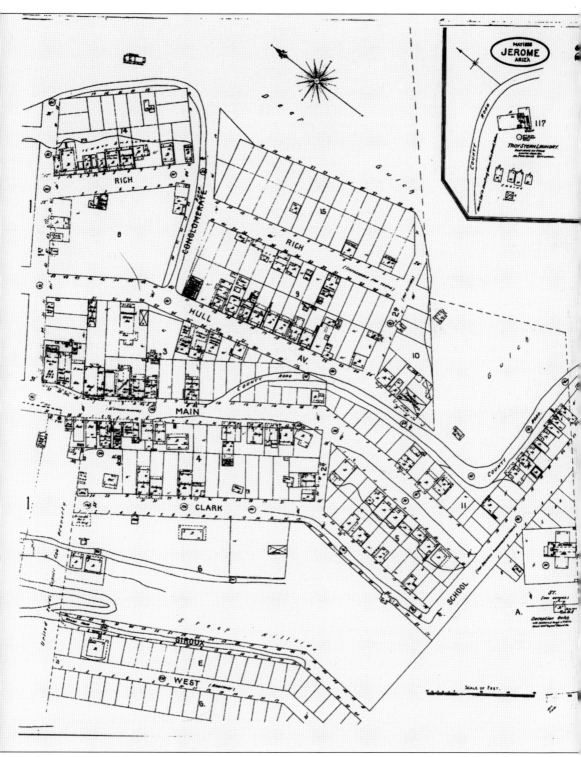

exist. (Courtesy Barbara "Blue" Bolter.)

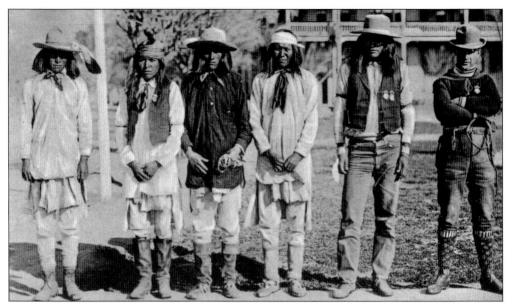

NATIVE AMERICANS. This postcard was published for the Boyd Drug Company in Jerome, Arizona. Many ancestral Puebloan Native Americans lived in this area. The Yavapais were mining Jerome's hills for minerals at the time the first pioneers arrived in this area in the mid-1800s.

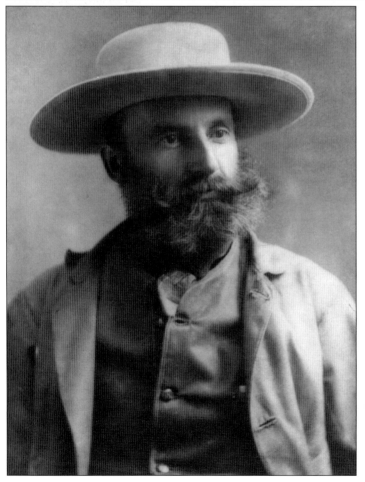

FREDERICK EVEREST MURRAY. Born in Canandaigua, New York, in 1849, Murray attended Yale, though he did not graduate. An early owner of the original Wade Hampton claim, Murray was responsible for seeking developmental capital from his cousin Eugene Jerome. Murray was later appointed by President Cleveland to be Jerome's second postmaster.

GEORGE WILLIAM HULL, 1899. Born in Berry, Massachusetts, in 1839, Hull was a powerful man. Hull was one of the early pioneers to come to Jerome; he owned much of the downtown district and was careful to hold mineral rights 25 feet below the surface to the lots he sold in town. Hull organized many mines and built a smelter in Walnut Canyon, also known as Hull Canyon. The remains of the smelter can be seen today on the road to Prescott. Hull served five terms in the house of the territorial legislature, one term as justice of the peace in Jerome, and two years as Jerome mayor.

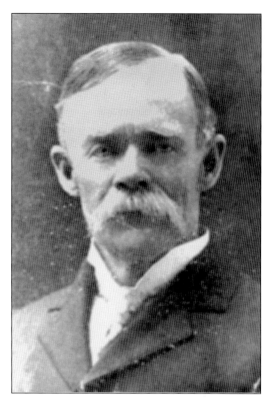

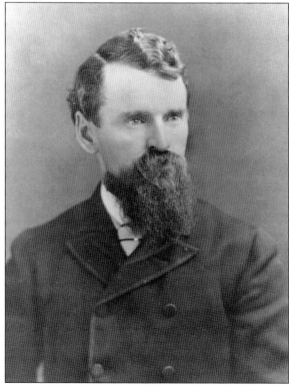

WILLIAM ANDREWS CLARK. This is an early photograph of Senator Clark, Jerome's most notable financial buccaneer. He was born in Pennsylvania in 1839. Clark really did move a mountain; he was a can-do man with a vision and purpose. Before Clark was 40, he was three times a millionaire. By the time he was 50, he was a multi-millionaire and the owner of the United Verde Copper Company.

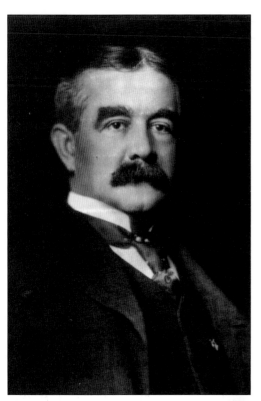

Eugene Murray Jerome. Jerome was born in Syracuse, New York, in 1845. He graduated from Williams College in 1867 and married Paulina Von Schneidau of Chicago. Jerome studied law in New York and maintained a profitable law practice. Paulina Von Schneidau Jerome bankrolled the mining camp that was then named Jerome in honor of her family name.

James Stuart Douglas ("Rawhide Jimmy"). Douglas was born in Quebec in 1867. He and his associates bought the Little Daisy Mine in 1912, renamed it the United Verde Extension (UVX), and discovered bonanza ores in 1914 and 1915. Jerome boomed.

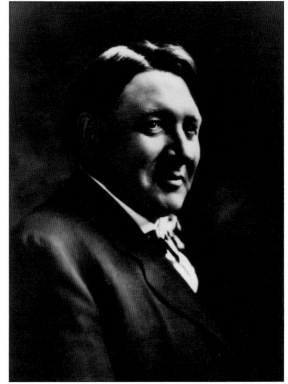

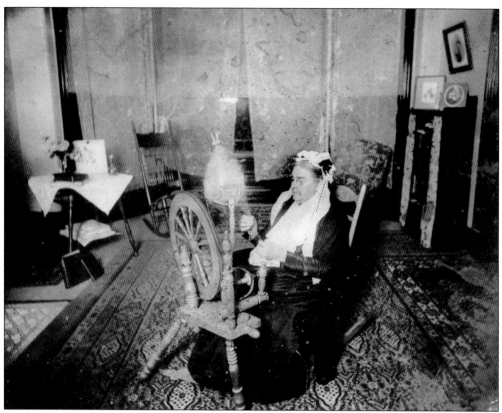

MARY ANDREWS CLARK. This fabulous, undated photograph depicts Mary Clark, the mother of Sen. William Andrews Clark, owner of the UVCC. Senator Clark was of Scottish, Irish, and Huguenot ancestry. His father was a farmer.

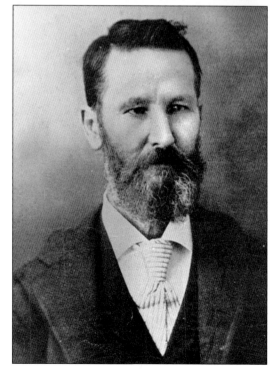

WILLIAM M. MUNDS. William Munds was elected Jerome's first mayor in 1899. The candidate for councilman who received the most votes was to be named mayor. This policy still holds in Jerome today. Munds died in 1903.

CLARENCE VICTOR HOPKINS. Hopkins was the chief civil engineer for the United Verde Copper Company and engineered the incredible Hopewell Tunnel, as well as many other astounding civil engineering projects for Senator Clark.

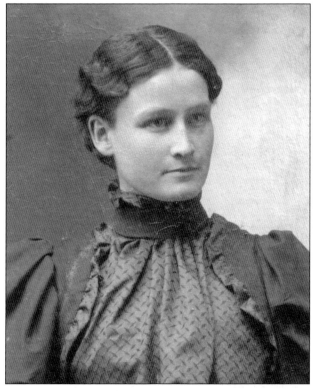

ANN DOHERTY HOPKINS. Herbert V. Young writes in *Ghosts of Cleopatra Hill*, "Hopkins was a woman of Jerome's High Society who went astray. . . . Her marriage to UVCC Chief Engineer, CV Hopkins, was unhappy. . . . Her marriage fell apart in 1921. Unable to tolerate the rumors of her husband's infidelity with a Jerome schoolteacher, Mrs. Hopkins broke down. On March 31, 1921, Mrs. Hopkins attacked Miss Lucille Gallagher, the other woman, with carbolic acid."

T. F. MILLER. T. F. Miller was the brother-in-law of Sen. William Andrews Clark. The T. F. Miller Company was the main merchandising house of Jerome and was open for business before the United Verde Copper Company smelter was built.

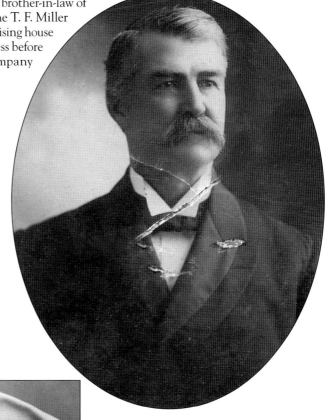

THOMAS E. CAMPBELL. Campbell became Arizona's second governor, was appointed Jerome's sixth postmaster by Pres. William McKinley, and was Jerome's first fire chief.

DR. CHARLES WINTER WOODS. The notes on the back of this photograph are unclear as to whether this is actually Dr. Woods, Jerome's first medical doctor, or perhaps a Jerome dentist. Jerry Vojnic recalls his mother, Mary, frequently praising the doctoring potions of Dr. Woods.

AN ACRE OF COPPER. This is one of the last photographs of Senator Clark before he died in 1925. There was an acre of copper bars stacked in the Clarkdale yards when the United Verde was sold to Phelps Dodge in 1935—90 million pounds of it, over 300,000 bars.

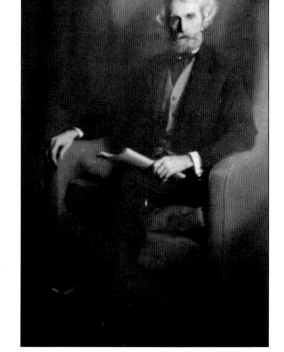

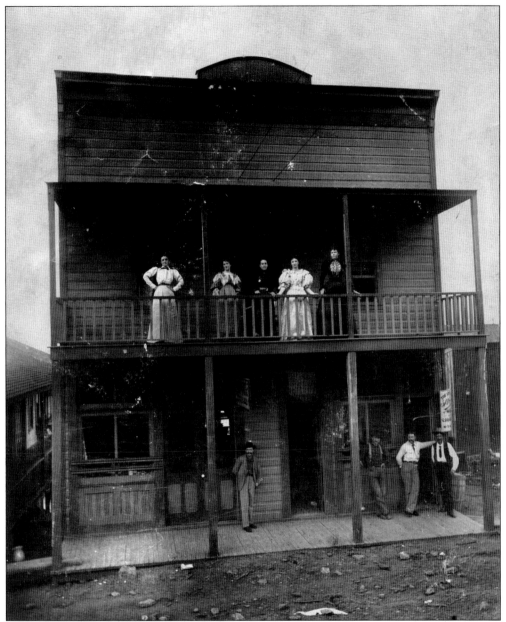

JENNIE BAUTER AND CATHOUSE, 1898. Jennie Bauter is one of Jerome's most well-known madams. There is a wonderful story told about a time when Jerome had one of its fires in the business district and Jennie offered all fire companies free passes for life if they would save her building. Her building was saved and still stands today! However, this photograph is of an earlier building of Jennie's that was destroyed by fire.

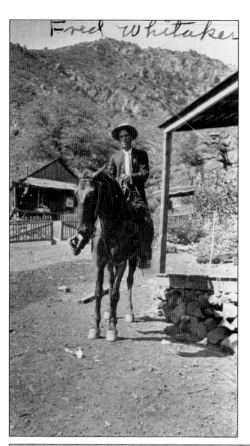

FRED WHITAKER. Whitaker was Jerome's town clerk in 1917 and the father of Edith Whitaker, notorious maverick newswoman of Jerome. This photograph was taken outside of their home in the Gulch area of Jerome.

PASSPORT OF MARY ANN SULLIVAN, 1924. Born in Wales on May 24, 1871, Mary Ann Sullivan was married to John M. Sullivan of the Sullivan Hotel and Apartments. Jerome has a town siren that goes off around noon. This siren was reportedly rung by Katie Sullivan every day. Jerry Vojnic also remembers a second siren that went off at 9:00 p.m. every day, marking curfew time for those under 18 years of age.

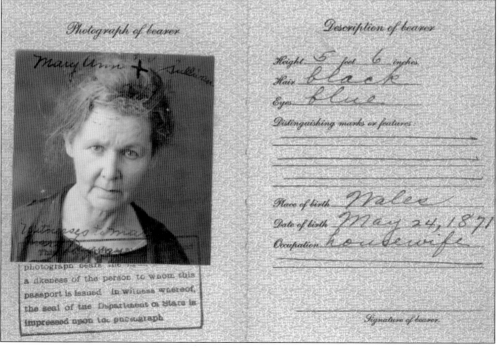

KITTY BOYD'S ORIGINAL BOARDINGHOUSE. This house burned to the ground in 1895. Kitty is the third from the left, dressed in black with her hands on her hips.

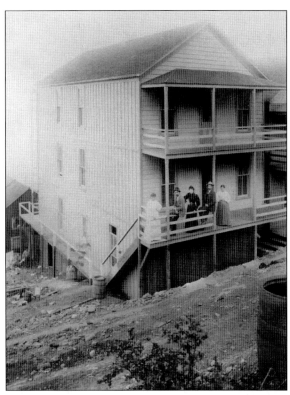

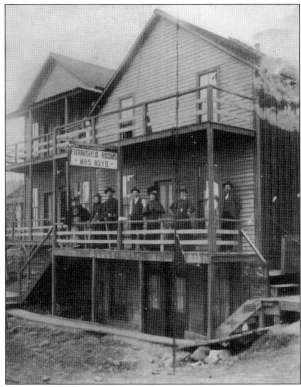

BOYD'S BOARDING. This photograph shows another early boardinghouse of Kitty Boyd. Boyd is second from right with her hands on her hips. World War I was in progress in 1915, copper was in high demand, and Jerome was bursting with activity. The UVCC and UVX were working three shifts a day. Most rooms were rented by shift, three men to a bed, each working a separate shift.

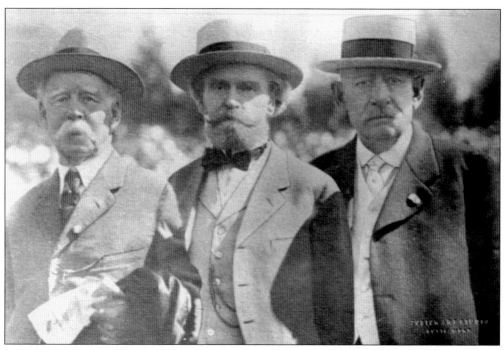

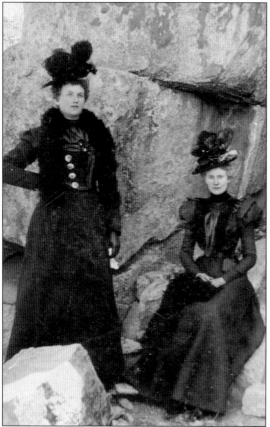

FINANCIAL BUCCANEERS. This photograph is of J. P. Morgan (left), Senator Clark (middle), and an unidentified gentleman. Young accurately writes in *Ghosts of Cleopatra Hill*, "The life and acts of William Andrews Clark can better be understood in the knowledge that he was a product of an era of financial buccaneering, an era which produced such noted or notorious operators as Jim Fish, Boss Tweed, John D. and William Rockefeller, J. P. Morgan."

"CENTRAL TO JEROME'S WELL-BEING." It is said that women were the civilizers of the wild Western towns. This is an undated photograph of Francis (left) and Thelma Thornbeck. As Young beautifully explains in *Ghosts of Cleopatra Hill*, "Although women were not allowed to work in the underground mines, their economic and social role was significant. They took care of homes and families and worked to support industries. They have always been central to Jerome's well-being."

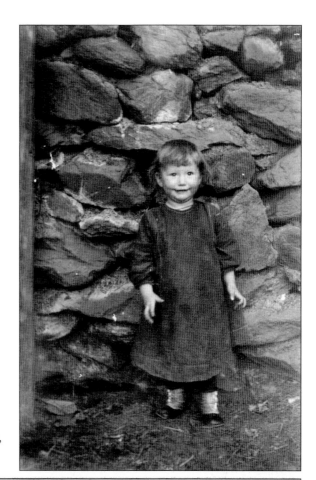

LORAINE HOWLE, 1914. This charming little 22-month-old girl is missing her papa. The postcard reads, "Dear Papa, are you coming home I wish you would L Loraine."

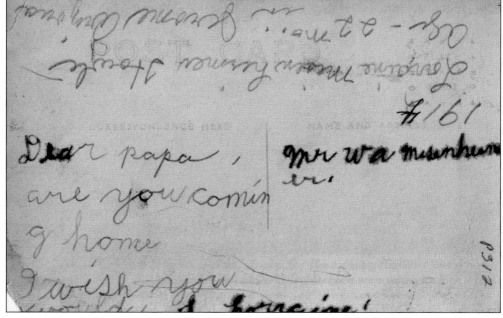

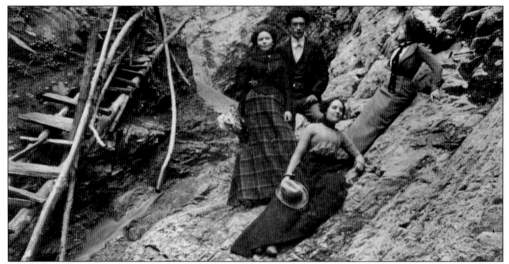

ADELAIDE, PEARL, AND TWO OTHERS. The only information we have on this photograph are the names of the first two women. Adelaide is on the left, and Pearl is in the middle. The 1882 mining camp reportedly consisted of a blacksmith shop, saloon, restaurant, barbershop, Hulls General Store, and a lodging house or two. Note the wonderful rock-climbing clothes of the ladies!

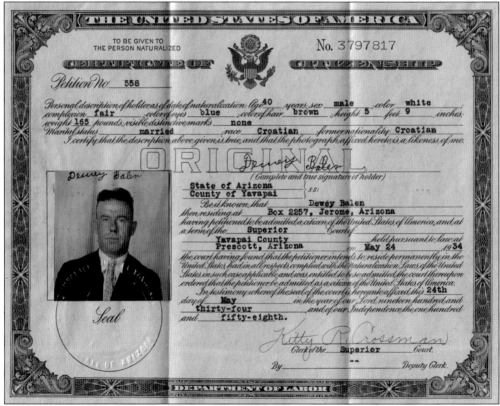

CITIZEN PAPERS. The hand-written note on the back of this citizen paper reads, "Name changed from Dujo Balen to Dewey Balen by order of the court May 24, 1934." Immigrants from all areas came to work the mines: Italian, Slavs, Irish, Mexican, French, Japanese, Apache, and Chinese.

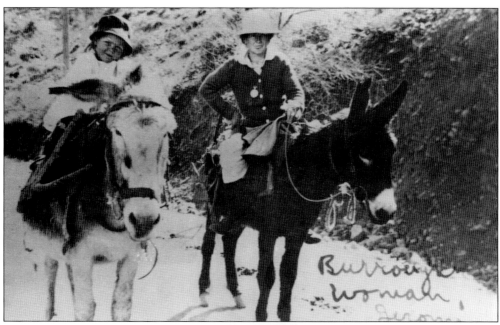

BURRO WOMAN, 1916–1917. This woman was known as the "burro woman." She would reportedly travel into Jerome from the surrounding hills somewhere—nobody seemed to know where. She had a boy and a girl and would occasionally come to Jerome for supplies.

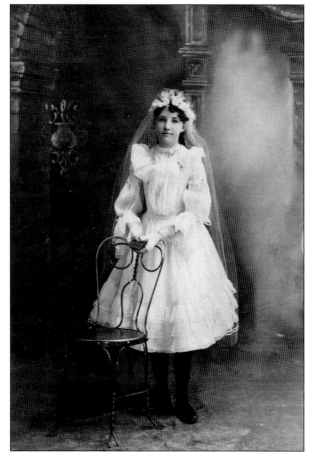

MARTHA THORNBECK. This is a photograph of Martha Thornbeck dressed for her first Holy Communion on February 24, 1904. Martha's family owned a Jerome bakery.

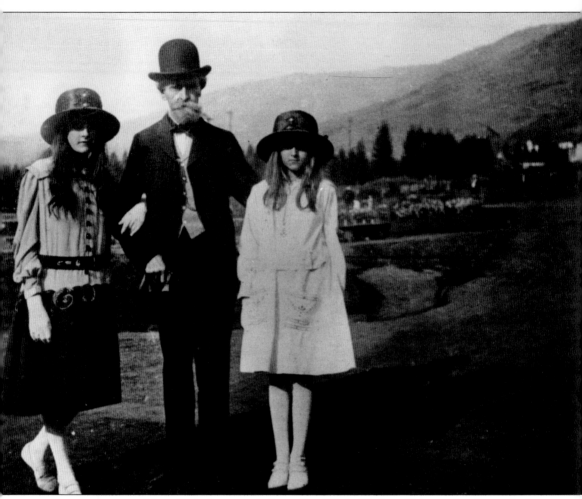

EXTRAORDINARY MAN. This photograph shows Sen. W. A. Clark and his two daughters, Andree Clark (left) and Huguette Clark (right), by his second wife, Anne La Chapelle. Young writes in *Ghosts of Cleopatra Hill*:

> Though it had been the senator's deepest wish that the ownership of the Unived Verde be forever retained in the family the UVCC sold to Phelps Dodge in 1935. . . . At that time the world had only begun to recover from the Great Depression; copper was still a drag on the market and advisors to the family convinced them that copper would never again be in scarce supply or worth more than ten cents a pound.

Two

Hard Work

This rugged Black Hills mining camp was isolated a mile high up Mingus Mountain with no roads or rail to it. Jerome's biggest challenge was transportation. This incredible undertaking is well described in Young's *Ghosts of Cleopatra Hill*:

> One of the first improvements made in early 1883 . . . was to build a wagon road to Fort Verde to connect with the military road to Prescott, and another across the hills to connect with the Prescott–Ash Fork wagon road to rail. Next a thirty-six inch water jacket blast furnace with a capacity of forty tons of ore a day was shipped from Chicago and freighted in by mule team from Ash Fork, together with a rock crusher and blower and steam engines to operate the blower and a hoist for a double compartment shaft on the Wade Hampton claim where the first ores were mined.

Jerome was said to be one giant tinderbox. There were four major fires that destroyed most of the business district between 1894 and 1899. The UVCC even had an underground fire burning ore-bearing sulfide masses in the upper levels of the mine since 1894. The fire burned for almost 20 years, until Clark had the smelter moved to Clarkdale and was able to extinguish the fire. Clark imported the specially trained "fire eaters" from the Rio Tinto Tin Mines in Spain to extinguish the fire. They were unsuccessful, so Clark had the entire mountain turned into an open-pit mine, built the Hopewell tunnel and three railroads, and moved the smelter to Clarkdale, a town he built for the mine.

Then there were the man-made explosions and earthquakes of the Marion 300 and the time the sliding jail slid across town and half the business district fell down.

There were four hospitals built in Jerome. The third and forth can still be visited today. There were several different churches as well. Today the Holy Family Catholic Church and the Haven Methodist Church are still open. The Christ Episcopal Church houses the offices of Jerome's Historical Society, and the Mexican Powderbox Church is a private residence.

Jerome had further work challenges when the Industrial Workers of the World, the "Wobblies," attempted to take over labor leadership in 1917.

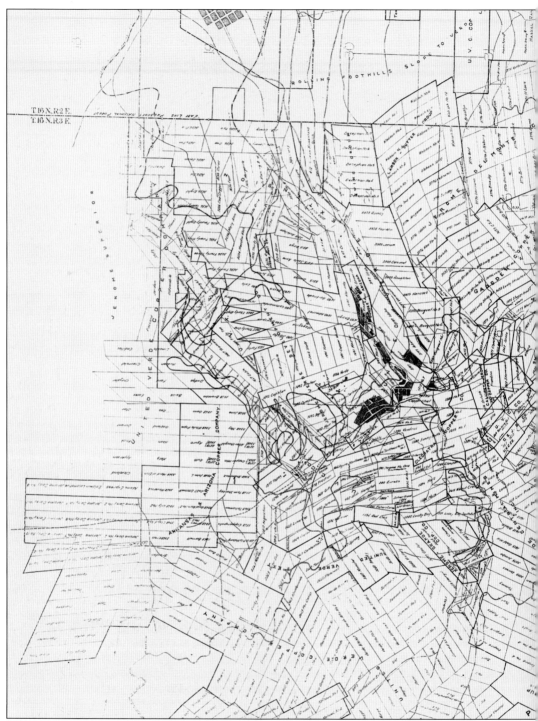

MAP OF JEROME MINING DISTRICT, 1926. The intensity of Jerome's boom is well stated by Young in *They Came to Jerome*: "When the bonanza discovery of the United Verde Extension Mining Company occurred, it triggered a boom the like of which had not been seen before in Northern Arizona. All lands not previously located in the Verde mining area, over the mountain and clean

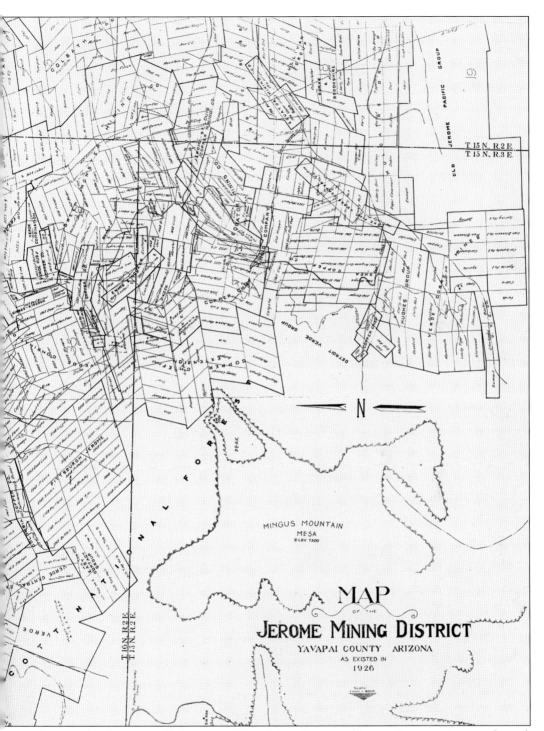

down to the river, were filed on as mining claims. Dozens of 'mining' companies were formed, a goodly number legitimate but many for wild cating purposes." This is a reprint of the original blueprint. (Author's collection.)

PANCHO VILLA. This photograph shows Earl Schurr on the left at Walnut Springs water tank camp, located about one mile from the UVCC. There is a reported story that Pancho Villa once worked here carrying water from the springs into Jerome via mule train to sell for domestic use. Villa's name is recorded in the register of the historic Bartlett Hotel. Local resident Manuel Sanchez, whose family worked in the Jerome mines, remembers his grandmother, Andrea Soqui, telling many stories of Pancho Villa.

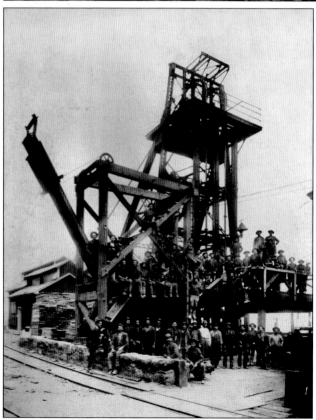

UVCC HEADFRAME. The proud crew of the UVCC is pictured standing on its headframe in 1900. Jerome's deepest shaft is 5280 feet (one mile) deep!

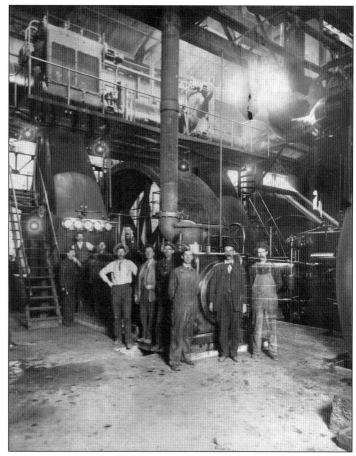

UVCC POWER ROOM, 1911. Just look at the size of this operation! It was reported that in the closing months of 1884, the United Verde smelter poured 11 million pounds of copper, which unbelievably contained close to 7 million ounces of silver and $1.5 million in gold. These results founded the widely reported belief that the silver and gold in the United Verde ores paid all the operating expenses—making the copper returns pure profit. These early photographs show the interior of the UVCC power room in 1911. The first photograph has a number of "ghost" images.

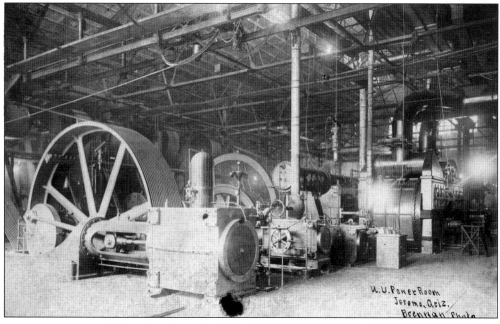

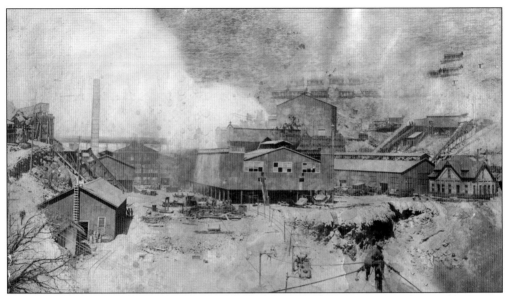

UVCC Tramway. An early photograph depicts the bustling UVCC smelter and a Jerome tramway around 1915.

Tramway to the UVCC. There were at least three aerial tramways operating in Jerome in the past. Clark and J. L. Giroux built the first tramway in 1891. This 6-mile-long tramway ran from the smelter along the western slope of Mingus, hauling coke and other supplies from Yeager Canyon, and the copper matte was hauled out.

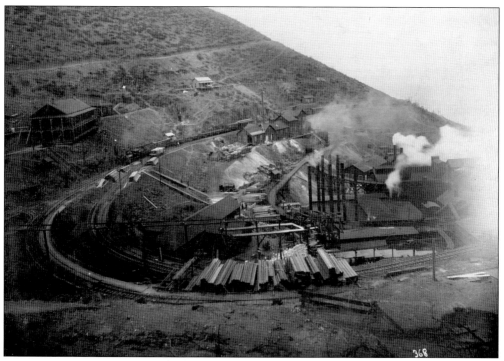

UNITED VERDE AND PACIFIC RAILROAD. This rare 1900 photograph captures both the UV&P Railroad and one of the UVCC tramways.

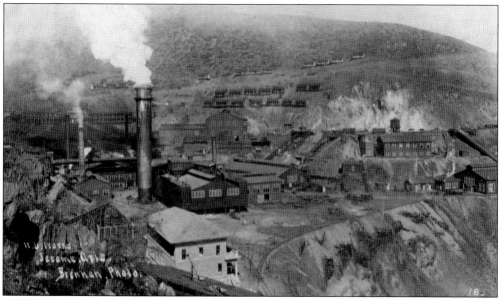

UVCC SMELTER. This is a photograph of Clark's original UVCC smelter prior to it being dismantled and moved to Clarkdale to create the open-pit mine. Wahmann writes in *Narrow Gauge to Jerome*, "There was a sawmill located between Jerome and Jerome Junction before the railroad was there. Fuel for the first Jerome smelter was originally supplied by timber from Woodchute Mountain, where logs were cut and slide down a chute. Some were sized for mine timbers and others converted into charcoal fuel and taken to Jerome by wagon teams."

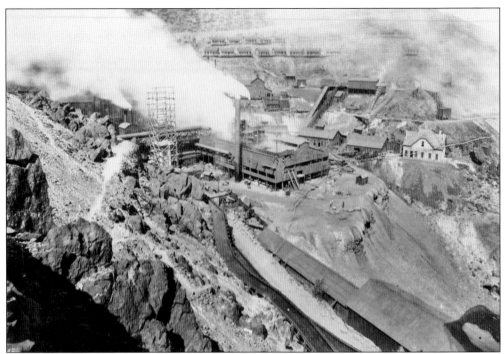

LIMESTONE FLUX. Fortunately, the limestone that was used for flux in the smelter was quarried not very far away, around the side of this hill. As reported by Wahmann in Narrow Gauge to Jerome: "Limestone was quarried at Smith Spur on the rail line between Jerome and Jerome Junction. . . . Flux acts to reduce the melting point of chemical properties in the ore, thus separating unwanted materials from the copper during the refining process."

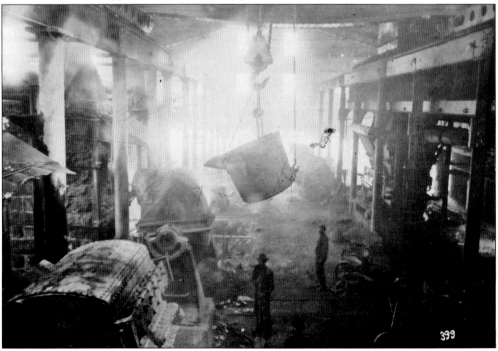

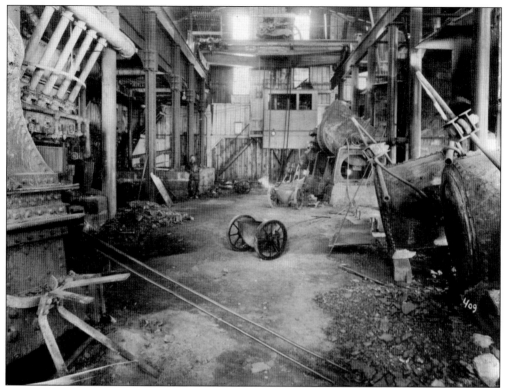

UVCC Smelter. This photograph was taken of the Jerome UVCC smelter after its closing on August 28, 1915, when the Jerome smelter was relocated to Clarkdale.

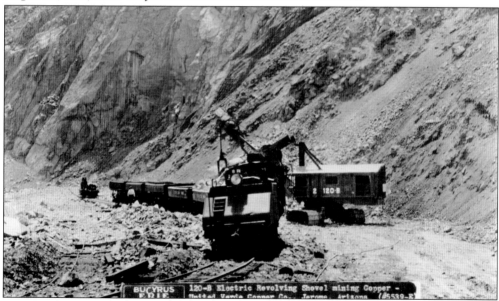

UVCC Electric Revolving Shovel. This is a photograph of the UVCC electric revolving shovel around 1900. The revolving shovel began a new era in mining. Where previously the men would muck the ore by hand, it could now be mucked in huge quantities by the revolving shovel, creating a faster and more efficient mining operation.

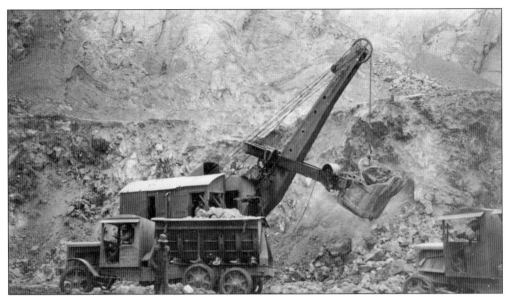

UVCC SHOVEL AND TRUCK. This photograph of a revolving shovel and side dump truck was taken around 1900. The use of heavy machinery allowed the miners to move tremendous amounts of ore in a single day.

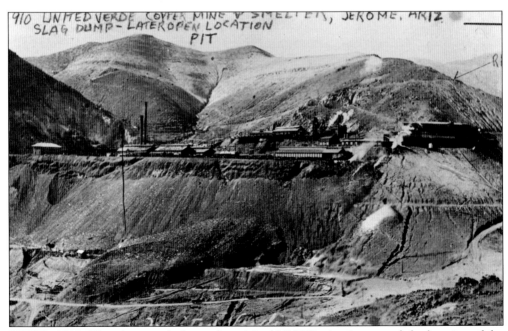

UVCC, 1910. This photograph shows the original UVCC mine intact and the location of the slag dump, railroad, and what would later become the open-pit mine.

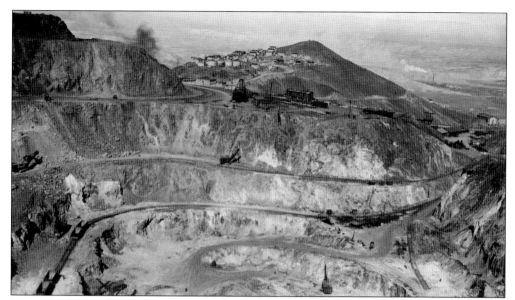

OPEN-PIT MINE. To create the open-pit mine, W. A. Clark had to move his smelter and the UV&P railroad, construct the Hopewell Tunnel, build three new railroads, and create a company town for his employees: Clarkdale. Clark accomplished this between 1911 and 1917. The new Clarkdale smelter opened in 1915.

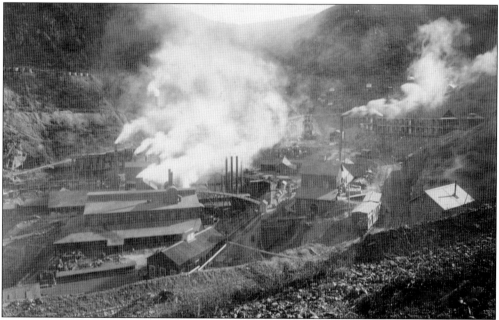

UVCC VIEWED FROM SUNSHINE HILL. The UVCC mine had fire burning in the shafts. James W. Brewer states in *Jerome, Story of Mines, Men, and Money*, "Beyond the fires were 9,708,923 tons of ore that averaged 3.47 percent copper, with 2.07 ounces of silver and .07 ounces of gold to the ton. On top of that ore lay 15,977,801 cubic yards of overburden. The ore couldn't be taken out by the usual tunnel and shaft method. Engineers calculated that it was worthwhile to peel off the heavy waste overburden to get to the ore beneath and an open pit operation was decided upon."

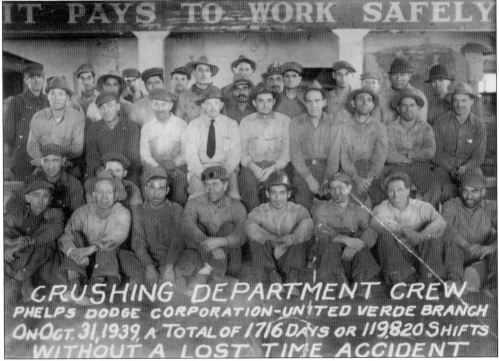

PHELPS DODGE SAFETY, 1939. Phelps Dodge bought the UVCC in 1935 from Clark's two daughters for a reported price of about $20 million.

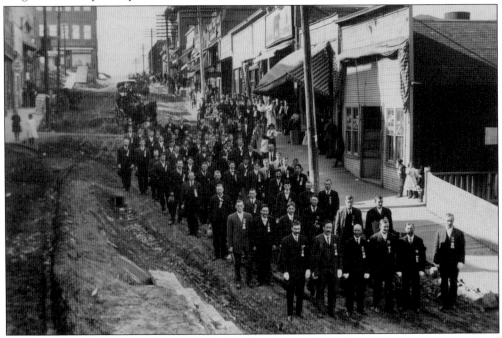

MAIN STREET FUNERAL, 1936. This funeral procession is pictured at the intersection of School and Main Streets. Jerome has a cemetery located in town and another two cemeteries located down the mountain in Clarkdale.

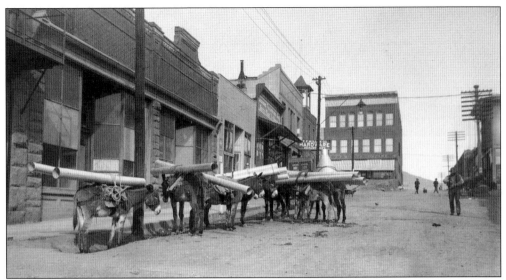

BURRO TRAIN. Note the telephone lines in the background. Jerome had two telephone companies. The Sunset Telephone and Telegraph Company opened in 1900 and Jerome Telephone and Telegraph in 1916. The UVCC constructed its own telegraph line concurrent with the railway. W. A. Clark was continually in contact with his managers in Jerome.

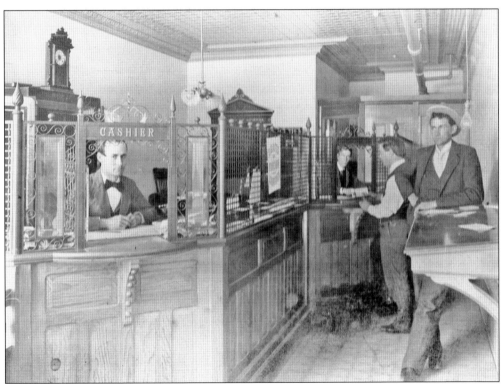

INTERIOR OF A JEROME BANK. This is an early photograph of the interior of one of Jerome's banks in the 1880s. The first recorded claims were less than 10 years old, and the town was booming. The cashier on the left is R. Smith, and the other gentlemen are unidentified.

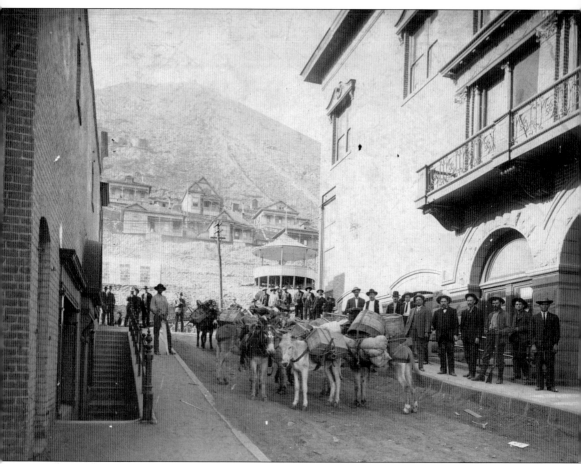

BURRO PACK TRAIN, 1910. This photograph was taken on First Avenue with the Bartlett Hotel on the right, the upper town park bandstand behind it, and Company Hill in the background. The entire block of buildings on the left was destroyed in a tremendous mine blast below. This was reportedly the same blast that caused the sliding jail to slide across the street to its present resting place. Apparently there was a particularly monstrous explosive charge of 260,000 pounds (equivalent to six freight car loads) that may have been the reason these buildings crumbled, the jail slid, and windows rattled throughout the Verde Valley.

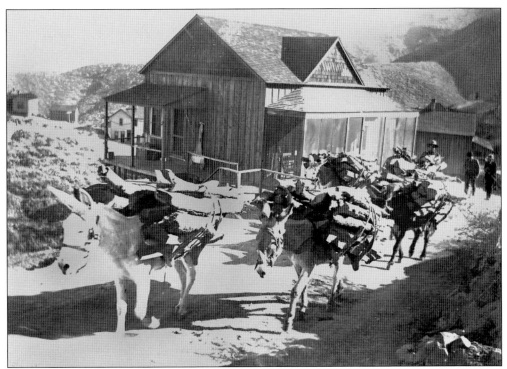

BURROS HAULING WOOD, 1899. The Dillion home in the background is typical of the early Jerome style. The smoke in Jerome was reported to be so thick that you could taste it in the back of your throat. There are many "smoke easements" in Jerome houses that date back to the times of the busy smelter fires.

GOOD MAXWELL! It was a hard mountain with a lot of hard work, requiring some hard play to balance. This c. 1922 photograph depicts 17 men outside a drugstore by a man in a car. The sign on the car reads "Good Maxwell—still running. Reese and Amster."

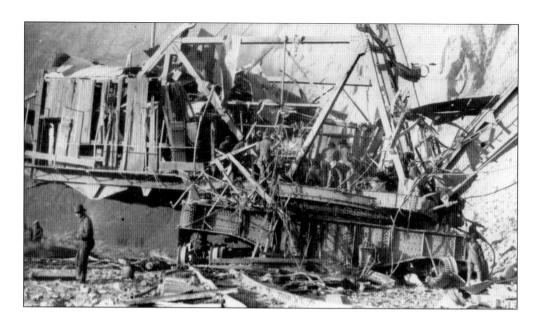

MARION 300. The Marion 300 was built for use on the Panama Canal but was acquired by the United Verde on a World War I priority order to increase wartime copper production. The shovel was destroyed in 1926, when it dug into an unexploded coyote hole; two men were killed instantly.

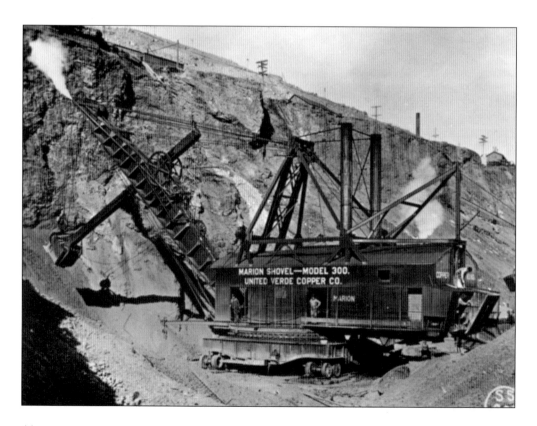

UVX, 1930. There was reportedly an ordinance that told residents if they were maimed or injured in such a way as to cause fright to the women and children of Jerome, they were prohibited from using the main streets of Jerome and must travel on the alleyways.

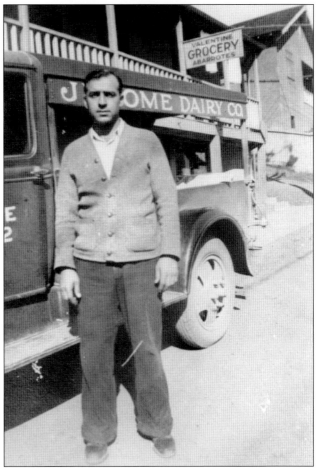

JOE PEDONE, 1933. Joe is standing next to a Jerome Dairy Company truck outside Valentine Grocery Market on Center Street.

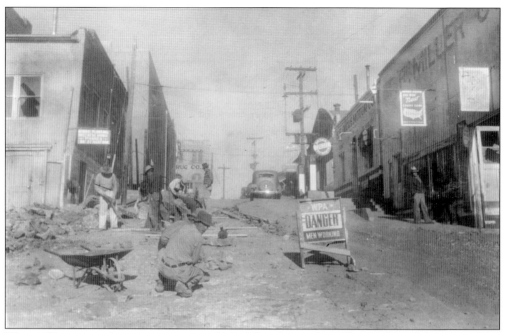

WORKS PROGRESS ADMINISTRATION, 1936. After the stock market crash and the start of the Great Depression, Jerome fell on hard times in 1932 when the UVCC closed its mine. Many of the miners scattered to WPA jobs. Fortunately many WPA jobs were located in Jerome. A great deal of the WPA work performed in Jerome is priceless to the town's infrastructure and still visible today.

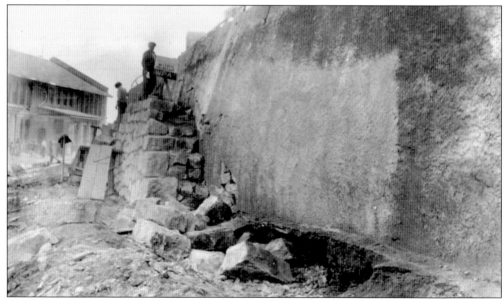

WPA SCHOOL WALL. Just barely visible is an old Jerome grammar school in the background. This grammar school building is still standing and now houses the Jerome town offices, court, Humane Society, artists' studios, and library. The Jerome librarian, Kathleen Jarvis, describes the Jerome library as "Jerome's living room, not a 'shushing' library." It is a warm and inviting library, and there is coffee and popcorn available for guests as well as high-speed Internet.

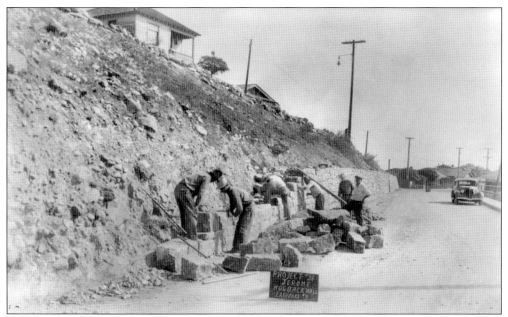

WPA ON HOGBACK. The WPA is also responsible for the large rock cobblestone of many of Jerome's streets. This photograph is of an excellently built WPA solid rock wall. Jerome resident Walter Johnson reported finding a stash of old marbles hidden in an old rock wall he was rebuilding—which goes to show that at least one person lost his marbles in Jerome!

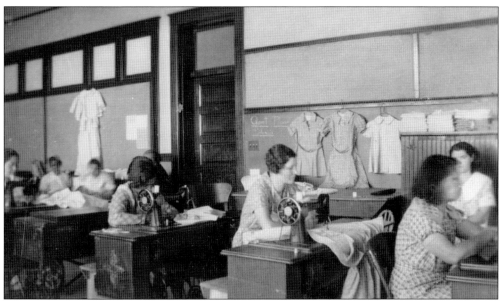

WPA SEWING ROOM, JEROME, 1936. This photograph shows the WPA sewing room in Jerome.

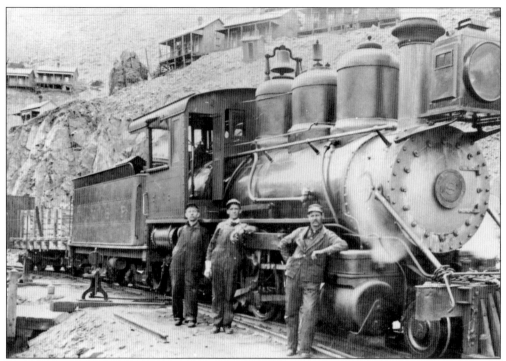

NARROW-GAUGE. One of the narrow-gauge railroad engines at the UVCC is pictured here. George McMillion is in the center. The narrow-gauge line ran from Jerome Junction to Jerome, through 187 curves and 28 bridges in its short 27 miles.

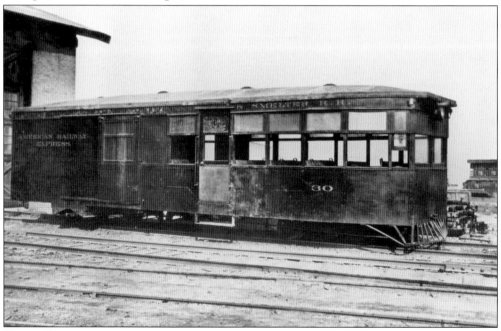

VERDE TUNNEL AND SMELTER RAILROAD CAR, 1923. The Hopewell Tunnel is 13 feet wide and 10 feet high and accommodates two tracks for a full-fledged standard-gauge train on the Verde Tunnel and Smelter Railroad.

NARROW-GAUGE RAILWAY EXPRESS OFFICE, 1917. This photograph shows agent Gordon Murray on the left and cashier Roy Boyd on right.

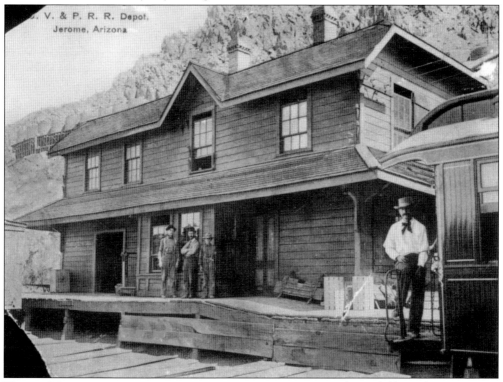

UNITED VERDE AND PACIFIC RAILROAD DEPOT. Jerome was easily available to the West Coast (hence "Pacific" in the name) and the world after the railroad's arrival.

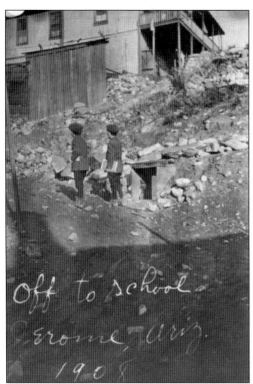

OFF TO SCHOOL. Two young Jerome schoolboys head off to school in 1908. Note how properly dressed they are.

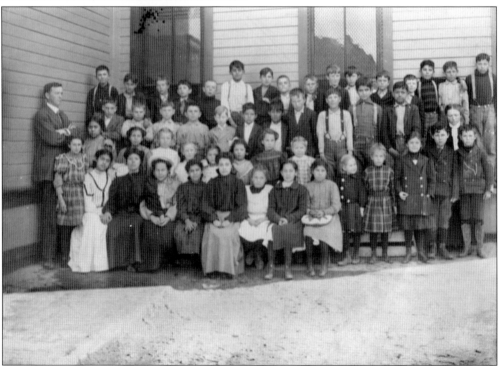

JEROME THIRD-GRADE CLASS, 1908. The gentleman standing on the left is Benjamin H. Scudder. Nita Scudder is the third girl from the right; she has white buttons and her chin is sticking out.

JEROME HIGH SCHOOL, 1914. This building is no longer standing. The high school buildings located on the edge of town when approaching from Cottonwood/Sedona currently house fabulous artist studios and a wooden furniture shop.

JEROME GRAMMAR SCHOOL. This building is no longer standing. There are currently no active public schools in Jerome. Most of the local students attend school in Clarkdale, Cottonwood, or Prescott.

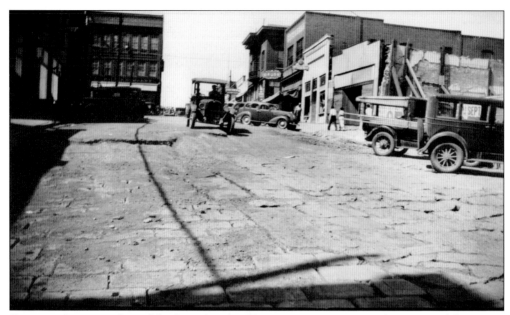

COBBLED STREETS. One of the finer details of Jerome's construction is that many of the streets of Jerome were laid out with large cobbles or rocks. This beautiful mosaic-like labor can be easily seen on County Road heading up to the open-pit mine and at the intersection of Verde Avenue and Scenic Highway 89A.

MELTING POT. Jerome was an excellent example of a melting pot. Miners came from all over the world to work "the West's wickedest city." This photograph was taken in 1898 of a few of Jerome's fine businessmen with their stylish clothes and mustaches. Unfortunately, September 11, 1898, is the date of the worst fire Jerome ever saw—the entire business district (including these buildings) and half of the residences were destroyed by fire.

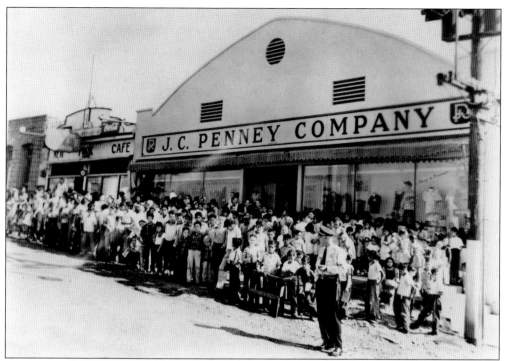

SPOOK HALL. This photograph was taken in the 1930s and shows townspeople waiting for one of Jerome's fabulous parades. Tom Cantrell, Jerome police chief, is in the foreground. The J. C. Penney store is now Lawrence Hall, also known as Spook Hall. Many town festivities are held at Spook Hall, including the not-to-be-missed annual Jerome Fireman's Halloween Masquerade Dance. Penney's closed its Jerome location in the 1950s.

HANDMADE HENDEY CAR. There is a handwritten note on the back of this photograph that reads: "Wife and daughter in Hendey car (not name on radiator), which he built himself from ground up."

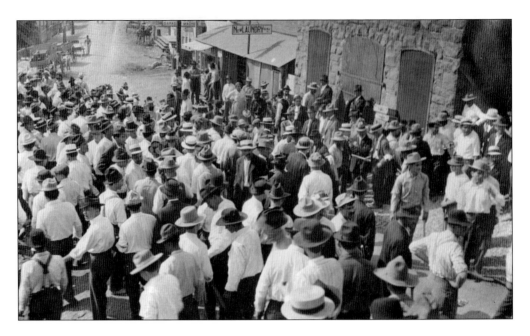

WOBBLIES AND ARMED CITIZEN COMMITTEE, 1917. The Industrial Workers of the World (IWW or Wobblies) attempted to take over labor leadership in Jerome and Clarkdale in 1917 and 1918. The Wobblies had called for a strike and reportedly represented all the dangers some Americans believed were apparent in "foreign" ideas. A "citizens committee" rounded up the Wobblies, loaded them onto cattle cars with armed guards, and shipped them out. They sent them west, but California refused to let them in. Eventually they were released in Kingman, Arizona, after giving their promise to refrain from further agitation and not to return to Jerome. Some also referred to this IWW group as the "I Won't Workers." The Wobblies were reportedly attempting to make a stand for higher wages and safer working conditions.

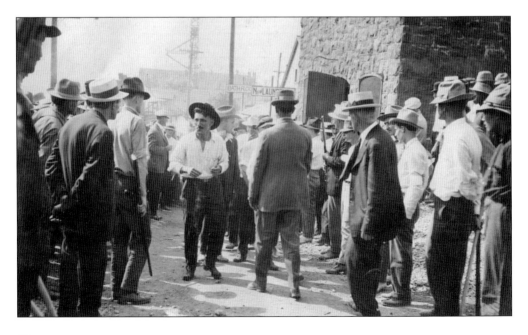

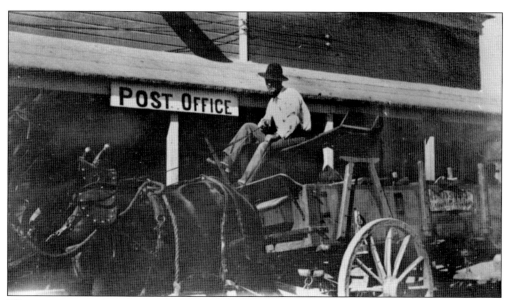

WAGON OUTSIDE JEROME POST OFFICE. This photograph shows the post office in Jerome at an unknown date. Note the construction of the wagon in the photograph.

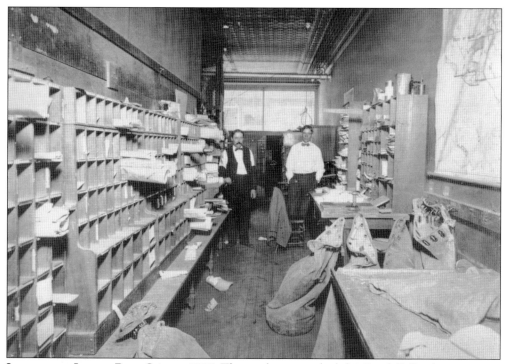

INTERIOR OF JEROME POST OFFICE, 1909. The gentleman on the left is Frank E. Smith, postmaster, and the gentleman on the right is Hugh Bradey Woolridge.

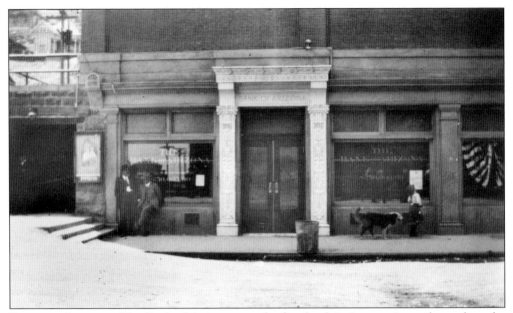

BANK OF ARIZONA. The Bank of Arizona was the first bank in Jerome. It was located on the bottom floor of the T. F. Miller building, across from the Connor Hotel. The building was sold for salvage and taken down in the 1950s. The site is currently where the Jerome recycle bins are located.

BANK OF JEROME. A man poses on a carriage outside the Bank of Jerome at an unknown date.

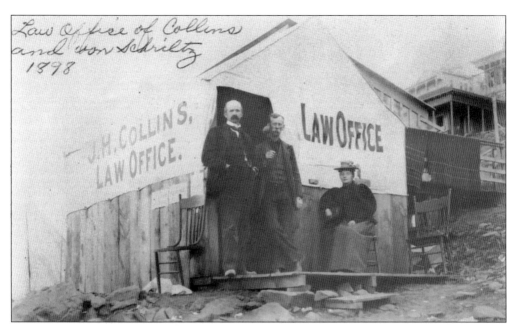

J. H. COLLINS LAW OFFICE, 1898. The Jerome business district burned to the ground four times between 1894 and 1899. This law office is an example of how the business people adapted by erecting tent buildings.

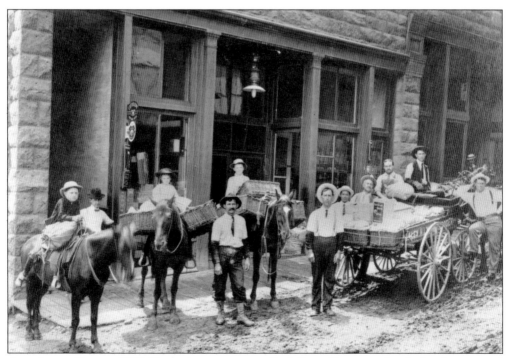

ALEX LYONS STORE, 1910. Groceries were reportedly delivered by wagon for the level streets and by packhorse for steeper roads and trails.

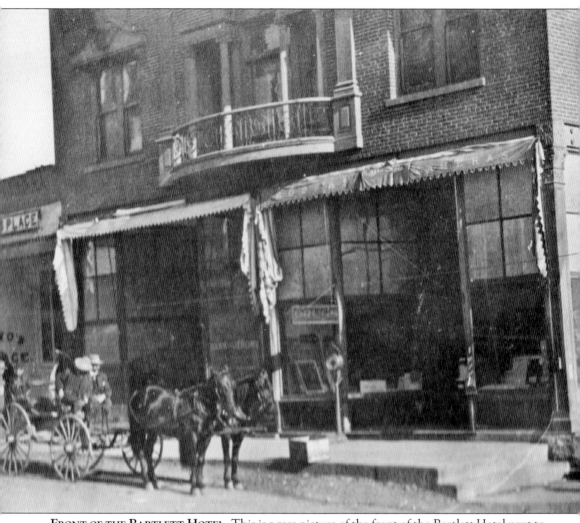

FRONT OF THE BARTLETT HOTEL. This is a rare picture of the front of the Bartlett Hotel next to Otto's Place. Many Jerome visitors today know this area as the site of the JHS coin toss. The JHS coin toss began as a special fund-raiser for the Bartlett Hotel in the 1970s. All monies collected from the coin toss are allocated to a special Bartlett Hotel fund. Many of Jerome's visitors delight in testing their arms by tossing coins into an assortment of challenging vintage artifacts used as targets, including a vintage toilet, mine car, and one of the WPA-built water closets.

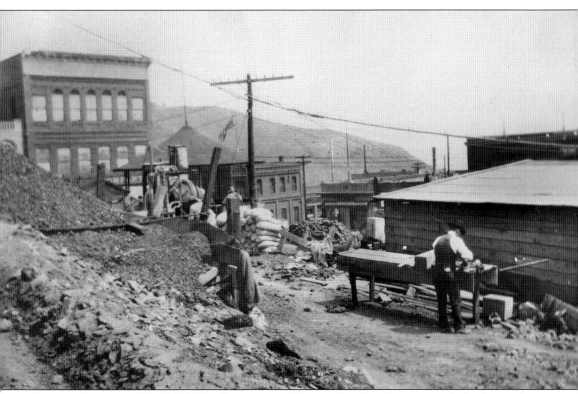

FOREVER BUILDING. The T. F. Miller Company and Connor Hotel buildings are in the background. The town of Jerome is always building. There were many fires that burned the business district down. Note the well-dressed style of the carpenter at work.

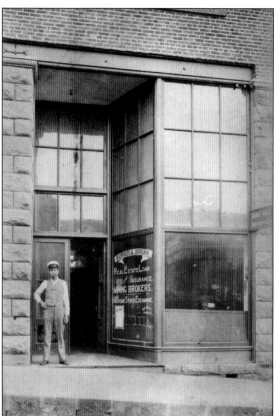

JEROME STOCK EXCHANGE. There were a number of stock exchanges in Jerome. The sign outside this building reads "Burkes & Jordon. Real Estate Loan & Insurance. Mining Brokers. Jerome Stock Exchange. Notary Public."

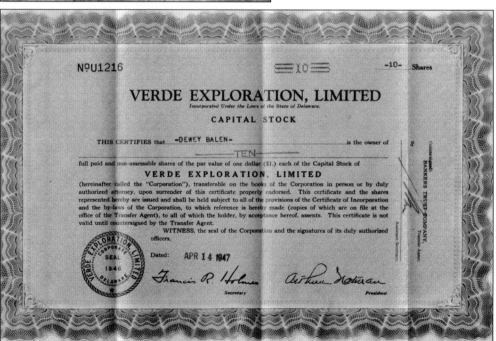

VERDE EXPLORATION STOCK, 1947. This photograph shows the Verde exploration stock of 1947.

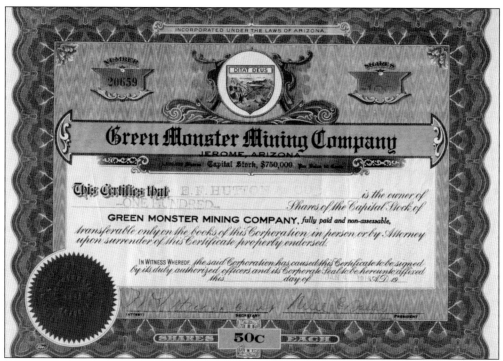

E. F. Hutton Investment. E. F. Hutton once owned this profitable Green Monster Mining Company stock certificate. This certificate is dated January 4, 1918. (Author's collection.)

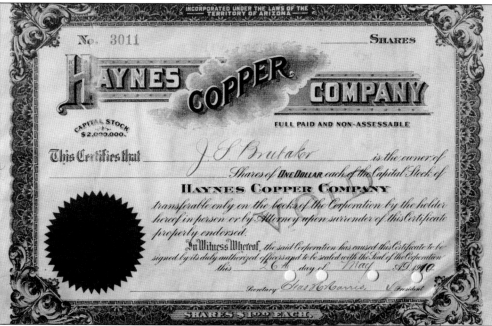

Haynes Copper Company Stock. Haynes, Arizona, is located about one mile past the Jerome fire station. The Haynes Copper Company dug for copper and found gold. Be sure to visit this historic old mine, as well as Don Robertson's Gold King Mine, with his huge vintage mining and automobile collection. (Author's collection.)

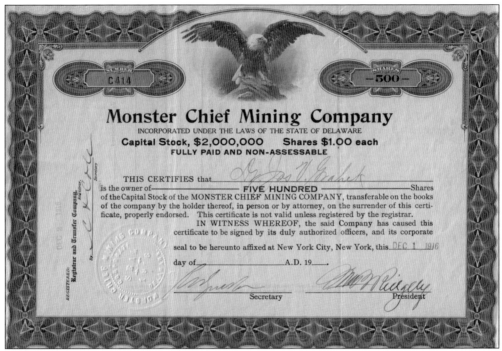

Monster Chief Mining Company Fraud Stock. Apparently this stock, dated December 1, 1916, was of a wildcatter's fraudulent mine and company whose name hinted of the profitable Green Monster Mining Company. (Author's collection.)

Three

KICK UP YOUR HEELS

There is little left to the imagination when one reads that Jerome was called "Arizona's Sodom and Gomorrah" and the "Wickedest Town in America." This rugged mining camp worked hard and played hard.

Jerome always had a scarcity of women during the mining era. The 1900 census reports only 22 percent of Jerome's population as female. It rose to 28 percent in 1910 and 36 percent female in 1920. These numbers reflected a ready market for prostitution, and Jerome had her share of madams and cribs. The remains of "Husband's Alley" and some of the "Tenderloin District" are still visible on Main Street.

Both Clark and Douglas provided entertainment outlets for their miners. A partial list of some of Jerome's entertainment includes saloons and women; drilling teams and mucking contests; hose, foot, sack, potato, and burro races; tug-of-war; scrambles for greased pigs; bronco riding; three bowling alleys; horseshoe pitching; two athletic clubs; social clubs; parades; boxing matches; baseball; football; trap shooting; a rifle club; golf; boating; swimming pools; poker and bridge; fishing; libraries; opera and theater; and even a circus in Jerome Junction.

Jerome has always had Town Park, which serves as a place to gather for relaxation and recreation. In the early days, there was a gazebo or bandstand and wood and barrel benches set up so people could listen to the music or watch the parades and contests on Main Street. In the 1930s, a miniature golf course called Dynky Lynx was installed in Town Park.

Today Jerome is a community of social gatherings with potlucks, Thanksgiving and Christmas dinners, outstanding music, and an annual community photograph. In addition, Jerome holds several festive annual events for all her welcomed visitors. Jerome celebrates these events: the Art Walk on the first Saturday of every month, *Out* in Jerome on the third Saturday of every month, the Jerome Garden Tour on the first weekend in May, the Jerome Historic Home Tour on the third weekend in May, Rockstock Music Festival generally on the last Saturday in August, the Jerome Copper Town Ball on the second Saturday in September, the Ghost Walk on the second Saturday in October, and the Halloween Masquerade Dance on the Saturday before Halloween.

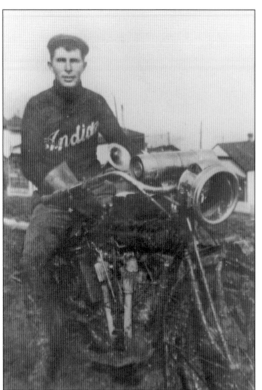

INDIAN MOTORCYCLE, 1912. This is a photograph of Harry Amster and his 1912 Indian motorcycle. Harry Amster rode his Indian motorcycle from California to Jerome when he moved to Jerome in the early 1900s. When Amster was in his 90s, he reportedly traveled back to Jerome from Phoenix on the back of his son's motorcycle. Jerome has always been a popular destination for motorcycles. Amster was half owner of the Reese and Amster garage and machine shop.

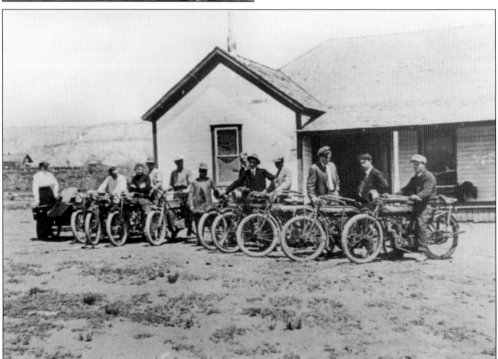

MOTORCYCLES IN JEROME. The handwritten note on the back of this photograph reads, "motorcycles at UVX site."

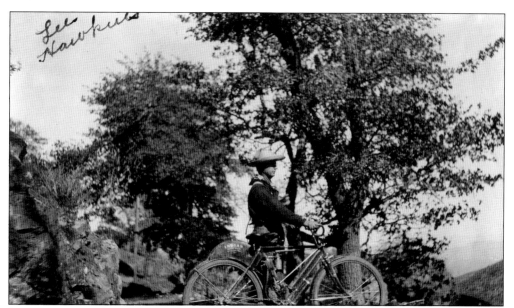

LEE HAWKINS AND BICYCLE. Visitors should be sure to see the vintage bike located in the JHS Mine Museum while in Jerome. Hawkins was a colorful character, as described by Young in *They Came to Jerome*: "He was hardly of age when he settled in Jerome and opened a dental office. People liked to twit him about his scant schooling in dentistry; a common story was that his first patients were horses. . . . Hawkins developed into a pretty good DDS but he liked to experiment. After killing a nerve in an aching tooth he would fill the cavity by driving in a cactus thorn! In large cavities he would put in a filling of asphalt!"

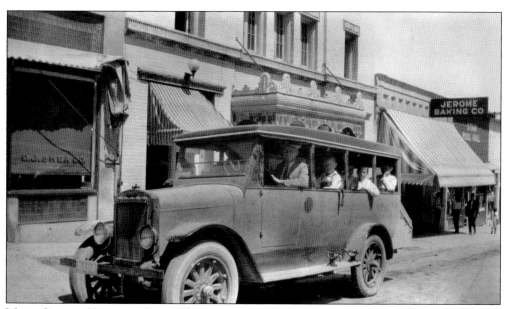

MAIN STREET TOURING CAR. What an elegant Jerome touring car. Note the Jerome Baking Company and Shea Company in the background.

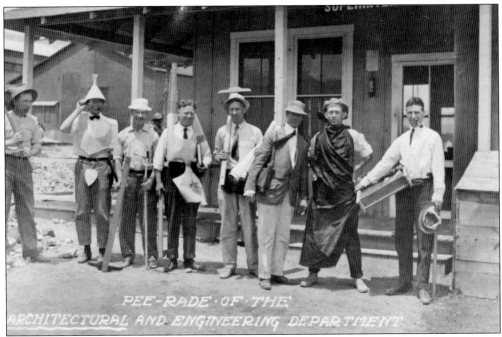

PEE-RADE, 1915. This whimsical photograph is of the UVCC architecture and engineering department at the dedication of their new office on May 25, 1915. These men deserved a "pee-rade" after their staggering engineering accomplishments of moving the smelter, digging tunnels, and building three new railroads and a new town so the UVCC could continue its mining operation.

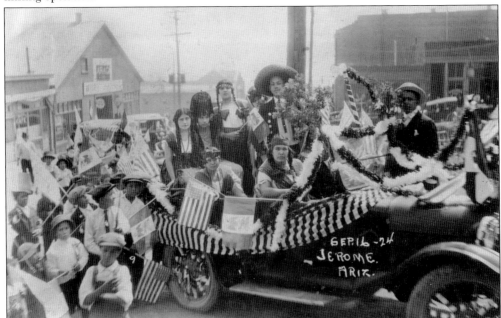

MEXICAN INDEPENDENCE DAY, 1924. There were many Jerome miners who came from Mexico. Mexican Independence Day was always celebrated with great fanfare, complete with music, dancing, and a parade with decorated floats.

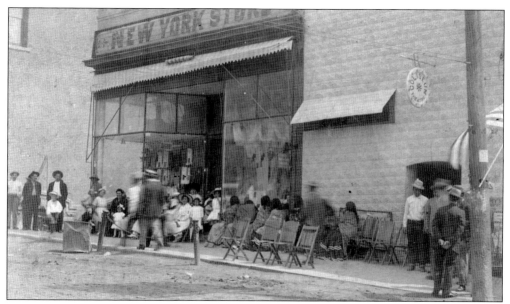

SEATED FOR PARADE, 1910. This photograph was taken outside the New York Store and Coliseum Theater of locals waiting for a parade. Joe Schuster is standing by the pole with his back turned to the camera. Currently, Jerome has a fabulous annual Fourth of July parade featuring Jerome's children and produced by the Jerome Kids Art Workshop. The children parade the main business district loop in colorful costumes fitting Jerome's great parade tradition.

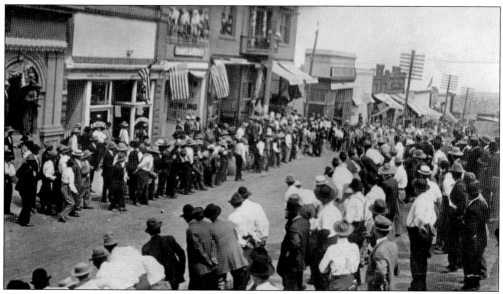

HERE THEY COME. Note that there are no cars parked on the street today. This may be a Fourth of July celebration, or possibly people are waiting for the finish of a hose cart race. It is interesting to see all the different awnings that were used on the various businesses.

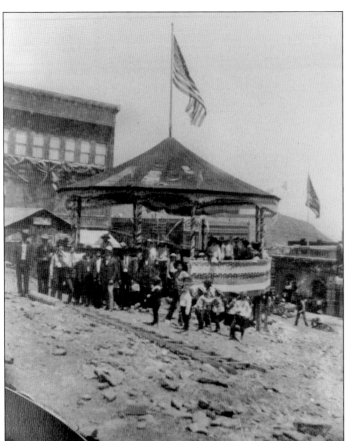

BANDSTAND GATHERING. The bandstand existed in Jerome's Town Park from 1900 to 1919. The bandstand was always a focus for music and celebration. This photograph shows the T. F. Miller Company Store on the left and the Connor Hotel on the right.

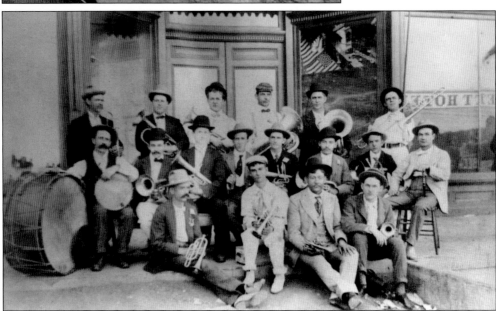

T. F. MILLER BAND, 1905. This photograph was taken outside the T. F. Miller Company Store. Karl Haydorn is in the first row with a white shirt.

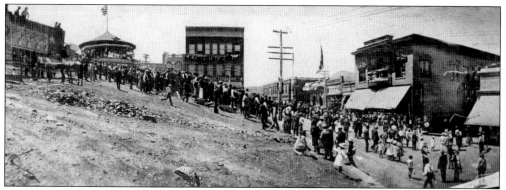

FESTIVAL AND BANDSTAND, 1919. Note the T. F. Miller Company Store and the Bartlett and Connor Hotels in the background at this town gathering.

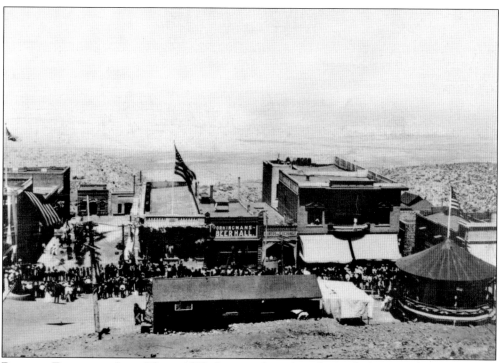

POSSIBLY FOURTH OF JULY. This c. 1919 photograph is of another early festive gathering on Main Street. Both the Bartlett Hotel and bandstand are still standing. The Beer Hall building is Paul and Jerry's Saloon today, which is the oldest family-run saloon in the state of Arizona. There are many exquisite original furnishings and details inside, including the marble bar and back bar, inscribed with "liquid carbonic," as well as the original tin ceiling.

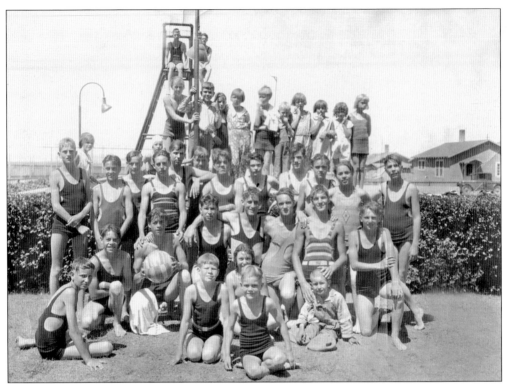

SWIMMING POOLS. W. A. Clark provided well for his miners. One of the benefits he provided was three different swimming pools in Jerome. This picture shows the 300-level swimming pool gang in 1929.

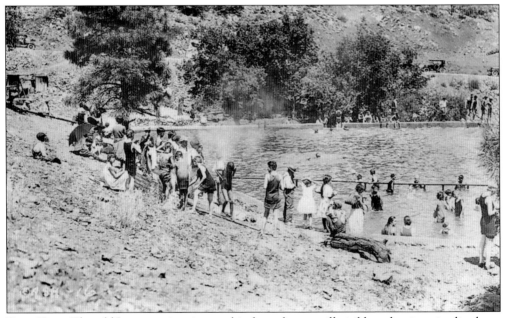

PLAY TIME. This old Jerome swimming pool is the only one still visible today; its ruins lie above Jerome off the highway to Prescott.

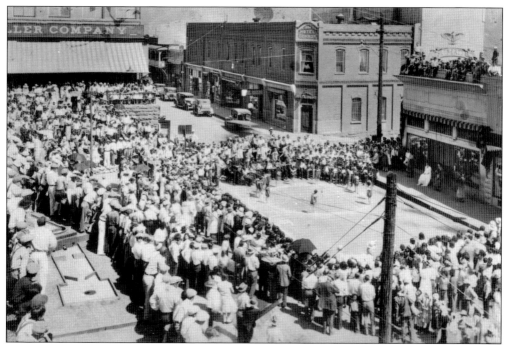

A BOXING EVENT HAPPENS. Jerome people always turned out. Note the people on top of the Fashion Saloon and the miniature golf course on the left in Town Park. This photograph was taken in the 1930s.

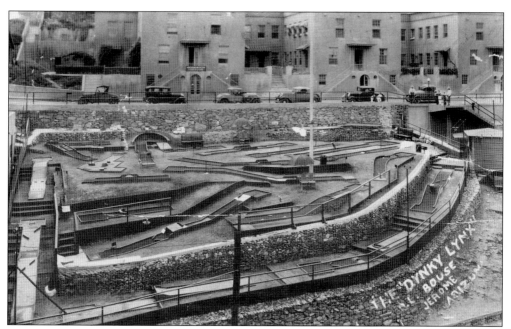

MINIATURE GOLF. The Dynky Lynx miniature golf course was located in the current Town Park, across from the JHS Mine Museum. Miniature golf courses appeared around the country in the 1930s. There are a number of Jerome locals who would love to bring this back.

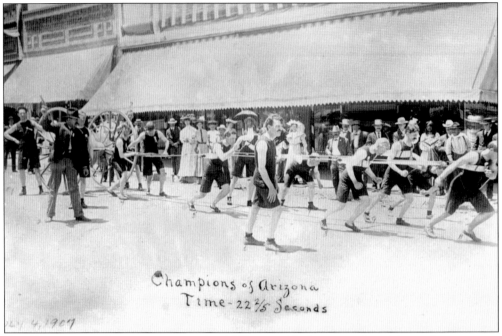

FIRE PROTECTION. Jerome incorporated in 1899 to provide fire protection with an adequate water supply and firefighting equipment. New building codes were adopted that compelled construction of stone or brick chimneys in new buildings. No tents or canvas-covered shacks were allowed inside city limits. Plans were made to raise money for new high-pressure water lines, hydrants, and tanks. Several hose companies were formed, and hose competition began. This photograph shows that this Jerome hose company was the current state champion.

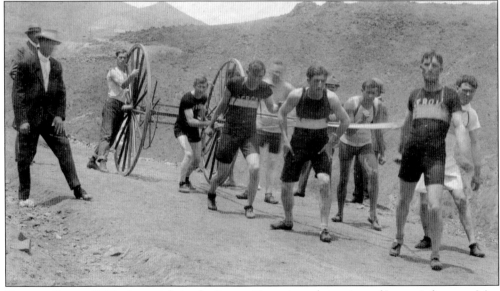

PRAISES SUNG, 1906. An article in the *Jerome News* sings the praises of Jerome's firemen. Mrs. Crater, who owned a large lodging house only a few feet from a fire, was asked if she was afraid of the fire reaching her building. She replied, "Oh! No. When I see the fire boys coming down the hill, I went back to my bed and to sleep again."

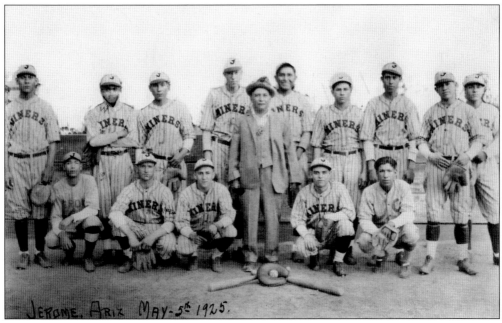

LET'S PLAY BALL. Jerome had its baseball teams. Clarkdale and Jerome had fierce competitive rivalries. One of Jerome's baseball teams was so outstanding that they even won the Northern Arizona State Championship in 1920.

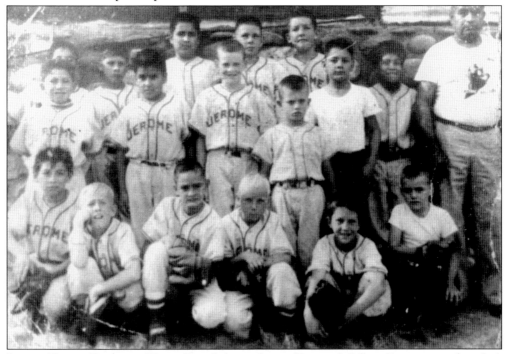

JEROME YOUTH BASEBALL TEAM. From left to right are (first row) Gilbert Enriquez, unidentified, ? Owens, and three unidentified; (second row) George Martinez, Tony Lozano, unidentified, Tommy Barrier, Henry Alverez, and Wayne Beecher; (third row) Manuel Fiqueros, Ernie Carillo, Balt Lozano, Butch Snyder, ? Brandt, and Pablo Martinez (coach).

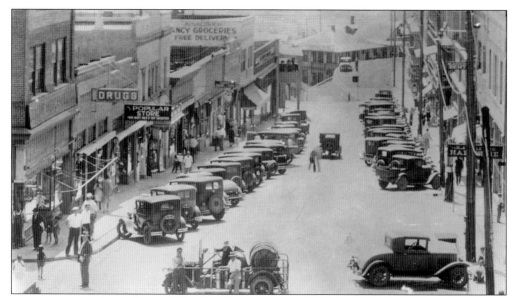

VANISHED BLOCK. The fire truck is curiously parked in the middle of the road at the intersection of First Avenue and Main Street. The entire block seen on the left is no longer standing as a result of a particularly large underground blast that caused a tremendous amount of damage to the Jerome business district.

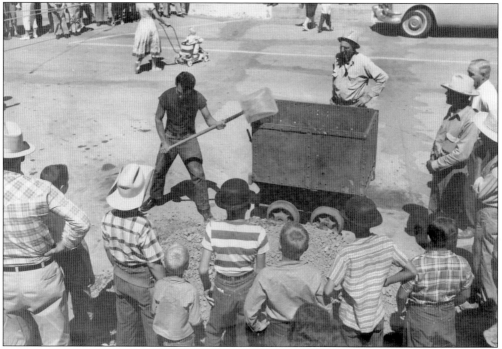

MUCKING CONTEST, 1955. Main Street was host to many different parades and celebrations. This one is of a mucking contest. Jerry Vojnic reports that Jerome was so dead in the 1950s and 1960s that they tried everything to draw people here: hose cart races, mucking contests, car races, and more. Vojnic reports, "You could sleep in the middle of the street, get up when the mail truck came through and then lay back down again."

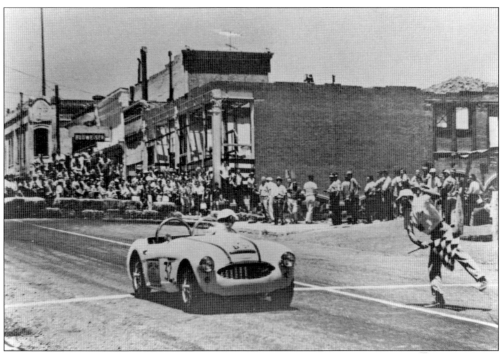

CARS RACE UP THE MOUNTAIN. The movie at the Jerome State Historic Park shows how Jerome had car races right through town in the 1950s and 1960s. This picture was taken in 1962. Can you hear Elvis or Fats Domino playing? In this photograph, one can see the ruins of the elegant Bartlett Hotel behind the crowd. The Four-Cylinder Car Club of Phoenix also cosponsored a race through Jerome on Scenic Highway 89A (Main Street) from 1957 to 1959.

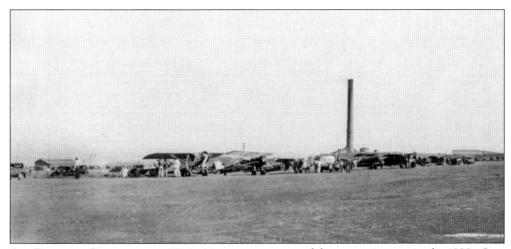

AIR RACES IN CLEMENCEAU, 1932. Air races were part of the entertainment in the 1930s. Sen. W. A. Clark's son, William Andrew Clark III (also called Tertius), died in a crash on this field in 1932.

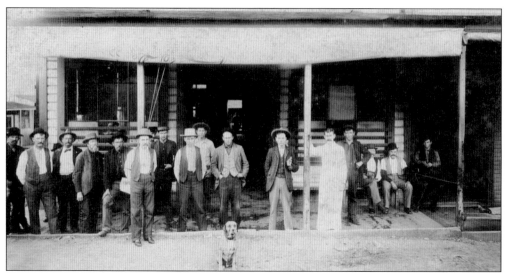

OUTSIDE THE FASHION SALOON. This photograph shows the Fashion Saloon before the fire in 1897. A handwritten note on the back of this photograph reads: "From left to right are Tom Miller, Tom Elder, a stud horse dealer, unidentified, J. B. Hoover, Sandy Roger, Manuel, cook at Grandview, William Pemberton, H. W. Watters, unidentified, Charley Stewart, George McKenzie, and Chas Hall."

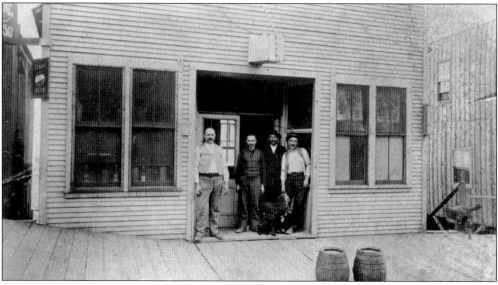

FOUNTAIN SALOON. Louis Paul Issoglio stands on the far left. There was a notice posted by Marshal J. W. Blankenship in November 1899 that read: "All able bodied persons not having visible means to maintain themselves and who live daily without employment or who are found loitering around and lodging in drinking saloons, bar-rooms, outhouses, houses of bad repute or any public places, such as sidewalks, street, alleys, vacant lots, plazas or parks or sheds, wagons or boxes, or who shall be found trespassing upon private premises without being able to give satisfactory account of themselves or who shall go from house to house or upon the street or any other place in said town begging for themselves or who habitually loiters or hangs around saloons, bar-rooms, bawdy houses and lives without visible means of support, will be arrested and placed in the chain-gang at labor on the streets of the Town of Jerome after 24 hours posting of this notice."

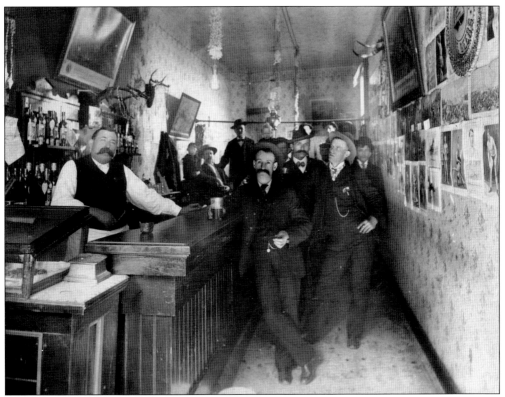

WINCHESTER'S BAR. Jerome reportedly had its own Coca-Cola bottling company, which was owned by S. Gibson and operated from the 1890s through the 1930s. There must have been some cola served here.

OPIUM ORDINANCE, 1906. Jerome had her ordinances. Who said that Jerome was the wickedest town in America? This ordinance is included because of Jerome's wicked reputation and because there was reportedly a huge chunk of opium found in the basement of the English Kitchen when the restaurant was opened back up after the ghost days.

PROHIBITING PLACES FOR OPIUM SMOKING 25

TOWN ORDINANCE No. 37.
PROHIBITING THE KEEPING OF PLACES FOR SMOKING OPIUM.

The Mayor and Town Council of the Town of Jerome do Ordain as Follows:

Section 1. Every person who opens or maintains, to be resorted to by other persons, any place where opium or any of its preparations are sold or given away to be smoked at such place, and any person who at such place sells or gives away any opium, or any of its preparations, then to be smoked or otherwise used, and every person who visits or resorts to any such place for the purpose of smoking opium or its said preparations is guilty of a misdemeanor, and upon conviction thereof shall be punished by a fine not exceeding three hundred dollars ($300) or by imprisonment in the city jail not exceeding six months, or by both such fine and imprisonment.

Sec. 2. Any person renting, leasing or using any house, room, apartment or other place as a resort for the purpose of indulging in the use of opium, or any preparation containing opium, or being the owner of such house, room or apartment, knowingly suffers it to be used for such purposes, shall be guilty of a misdemeanor.

Sec. 3. It shall be the duty of the Marshal, or his deputy or persons acting in official capacity as such of said town, to seize and carefully keep all cups, pipes, apparatus, boxes and things used for the purpose of eating, smoking and inhaling opium, and produce the same in court to be retained until the final disposition of any case in which said articles may be required as evidence, to then be destroyed by order of the court.

Ayes: Sutter, Holliday, Merrill, Dicus.
Nays: None.
Presented to the Mayor pro tem, for his signature and approval this 5th day of October, 1906.

F. H. Gorham, H. E. Dicus,
 Clerk. Mayor pro tem.

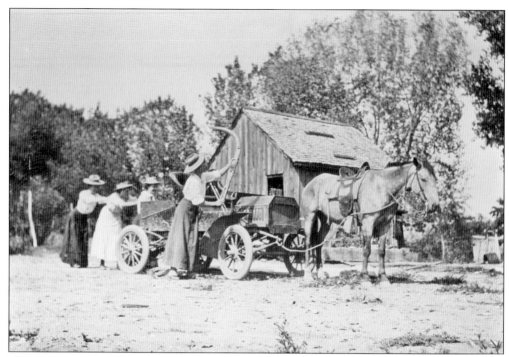

HANDMADE CAR. The note on the back of this photograph says that it is a handmade car. Apparently these folks needed a horse to pull it. This photograph was taken in the Gulch area of Jerome.

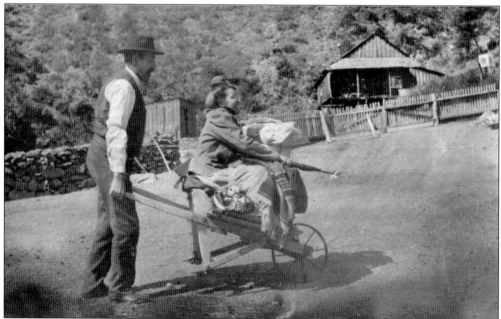

OLE GIVING EDITH A RIDE. Edith Whitaker and Ole horse around in the early 1900s. This photograph was taken at the Whitaker house in the Gulch, with the Hawkins house in the background. Jerome is covered with artifacts left from her mining heyday. A wheelbarrow very similar to this one was found in the author's yard.

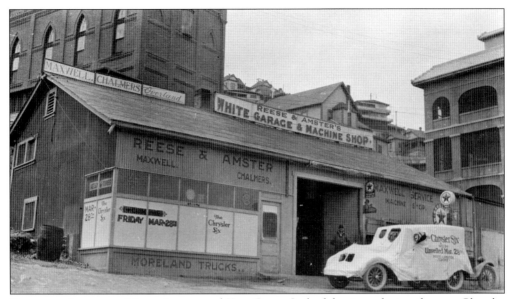

BUILDING SUSPENSE. Harry Amster and Kent Reese Sr. had fun introducing the new Chrysler Six in March 1924 at their garage and machine shop. The Holy Family Catholic Church is in the background. This building is still standing in Jerome today.

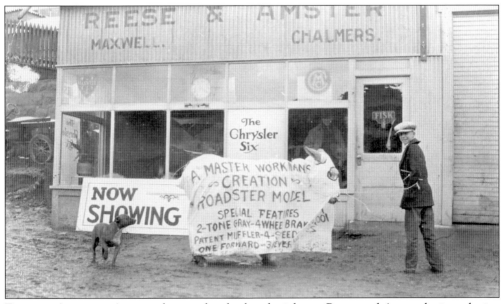

FOOLING AROUND. Apparently some locals played a joke on Reese and Amster by introducing their own roadster as a spoof on the 1924 Chrysler Six.

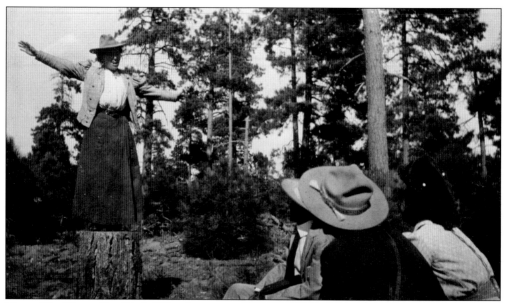

HEAR YE, HEAR YE. Edith Whitaker is speaking out on top of a tree stump. Whitaker was a well-known, independent, and outspoken woman. She was the editor of a local newspaper, the *Jerome Sun*. There have been many reported ghost sightings of the independent Whitaker.

WOMAN IN CAGE. This is not the ladies jail or the famous sliding jail of Jerome. This photograph is included for its curiosity. The authors would welcome input from readers who may have a clue what this could be about. The photograph came from the C. J. Beale Collection in the JHS archives.

Four

EQUALLY HARD MOUNTAIN

The workers at this mile-high, precariously perched mining camp had their work cut out for them on the isolated Black Hills Mountain, with four geological fault lines running through town, steep grades, wind, fires, snow, drought, and hardship.

Jerome was covered with pine, oak, and manzanita trees in the late 1800s. The trees were cut for lumber and mine timbers. The acid fumes from the smelter and ore-roasting pyres reportedly killed the smaller growth.

Clark had two wagon roads built to Jerome in the years 1882 and 1883. The first came from Prescott and Camp Verde to Jerome and the second from Dewey to Cherry Creek to Jerome. In *They Came to Jerome*, Herbert V. Young writes a beautiful description of the challenging grades on these roads:

> Multi-teamed freight wagons were used and there were heavy grades on the approach to the mines. The grade was as steep as 30 degrees in places. The wagon trains had to double up their teams and haul the loaded wagons one at a time over the hump. Heavy brakes operated with block and tackle were on all wagons, and to make sure there were no breakaways, behind the rear wheels of each wagon dragged by chains and crosswise of the direction of the wheels, were twelve-inch-square sections of timber. This blocked the wheels when the wagon rolled back.

There were at least three aerial tramways built to haul ore in Jerome. The first, built in 1891, was a 6-mile-long aerial tramway across the western slope of Mingus Mountain. Powered by steam engine, the tramcars were carried by cables and had the capacity to haul 300 pounds each. Coke and other mining supplies were hauled from Yaeger Canyon to the smelter, and the copper matte was sent out. This grand tramway was destroyed by a windstorm.

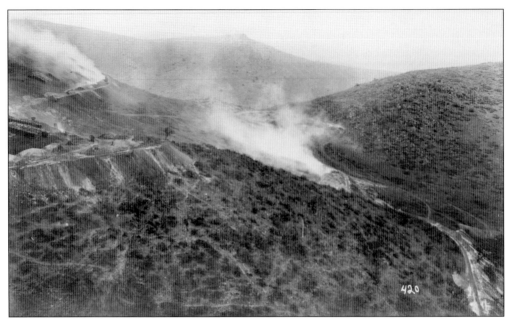

MINE FIRES. Sulfide ores had ignited underground in the UVCC mine. The sulfide dust was highly combustible and would ignite spontaneously. One of the underground fires at the UVCC burned for 20 years. Looking at this picture, it is easy to imagine Jerome in her busy heyday, with sulfur, smoke, and cooking smells and the sounds of all the machinery, animals, and activity.

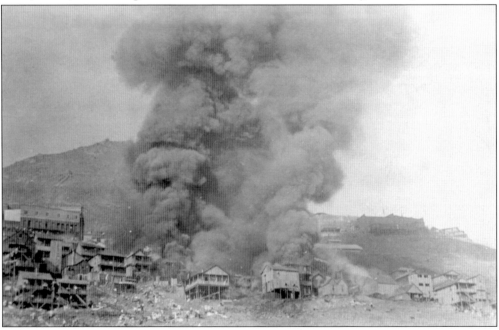

BUSINESS DISTRICT BURNING. Jerome suffered four major fires, losing much of the business district each time, from 1894 to 1899. In 1894, a block or two in the business district burned; on December 24, 1897, twelve buildings were destroyed; on September 11, 1898, fire destroyed all of Jerome's business area and half of the residences; and on May 19, 1899, thirty businesses and 40 dwellings burned.

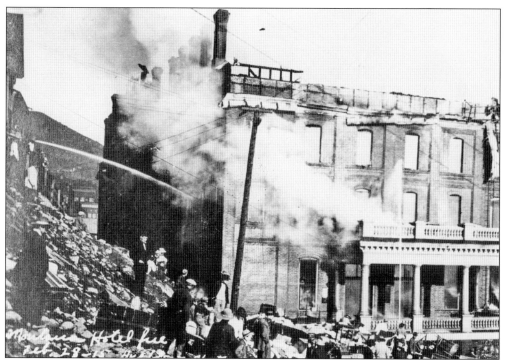

MONTANA BURNS! The spectacular Montana Hotel burned to the ground on February 28, 1915. Jerome was plagued with many fires. The town earlier incorporated in 1899 in order to help provide fire safety.

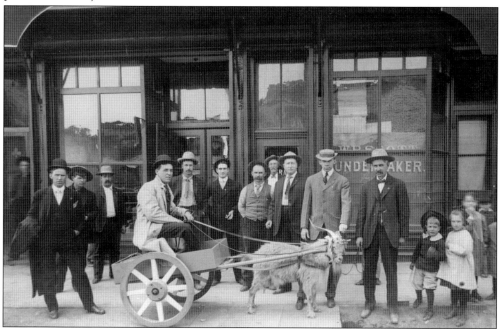

INITIATION RITE. These men and children are in front of the undertaker's business at the Boyd Hotel. Reportedly new members of the lodge got to ride the goat around town as part of the initiation rite of the Benevolent Order of Elks.

JEROME HOSPITAL, 1915. Shown in this photograph is nurse Lydia Nords at the Jerome Hospital. Jerome had four hospitals during her heyday. Only the third and fourth hospital buildings remain standing today.

ORDINANCE NO. 85. This Jerome ordinance allowed the health officer to restrict foul odors from being released in the community.

ORDINANCE No. 85

The Mayor and Common Council of the Town of Jerome do Ordain as Follows:

Section 1. The Health Officer is hereby authorized and empowered to make such rules and regulations required to be observed by the inhabitants of said Town, as he may deem necessary, to protect said inhabitants against contagious, malignant or infectious diseases.

Sec. 2. To make or cause to be made, whenever he shall deem it necessary for the protection of the health of the inhabitants of said Town, complete and careful examination of any hotel, restaurant, public houses, shops, buildings, tenements, dwellings, lots, grounds and all open places and all sinks, vaults, privies, sewers and drains in said Town.

Sec. 3. Whenever any hotel, restaurant, house or other building in said Town, shall be found to be encumbered with any foul or stagnant water, filth or any putrid or unwholesome or offensive substance or nuisance, or cause or source of sickness or disease, or shall be found in any such condition as to cause any unhealthy or offensive exhalation, odor or stench to arise therefrom, the Health Officer shall notify the owner, agent or lessee of such premises to abate such nuisance within thirty days thereafter.

Any person who shall violate the provisions of this ordinance shall be guilty of a misdemeanor and upon conviction thereof, shall be fined not less than Ten Dollars nor more than One Hundred Dollars.

Approved December 11th, 1917. J. J. Cain,
Attest: Mayor.
Fred Whitaker, Town Clerk.

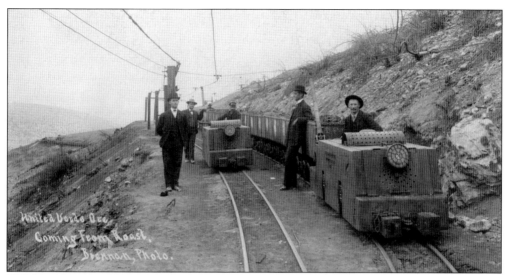

UV Ore Coming from Roast. This photograph shows Ralph Smith at far left. Imagine being dressed in these fine clothes for this work.

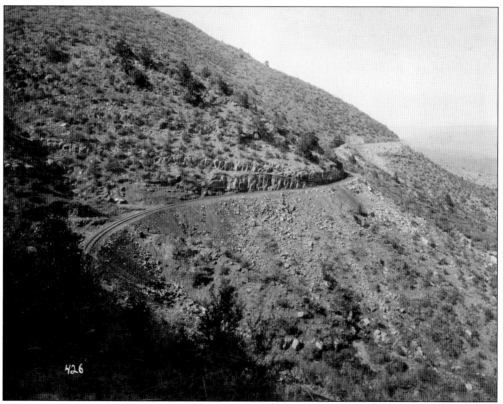

Corkscrew Line. In 1893, W. A. Clark built a narrow-gauge railroad, the United Verde and Pacific, to connect Jerome to Ash Fork, Prescott, and Phoenix. Abandoned and scrapped in 1920, it was called the "crookedest railroad in the world." The tracks of the UV&P railroad are no longer present. One can now drive this old railroad bed in a good 4x4 all the way to Williams, Arizona.

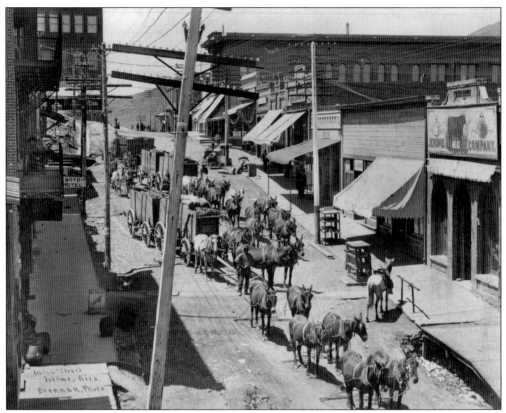

HAULING ORE. Moving the rich ore to the smelter and to the market was the main profit challenge the early miners faced. Most of the buildings located on the right side of this photograph were lost in one of Jerome's slides. The buildings housing Janelle's Gallery, Belgian Jennie's Bordello Pizzeria, and the Flatiron Café are still located here today. The owners of Belgian Jennie's say that they do not have cell reception in their building because it was constructed with slag from the mine mixed with cement.

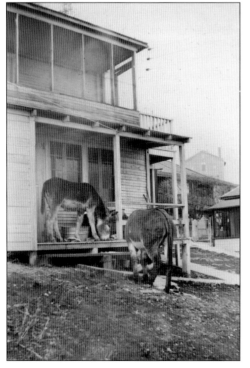

ARIZONA CANARIES. These burros were caught grazing on this porch in October 1941. The burro was a familiar sight in early Jerome. They were used for packing firewood and delivering supplies, and when no longer needed, they would be turned loose to roam at will.

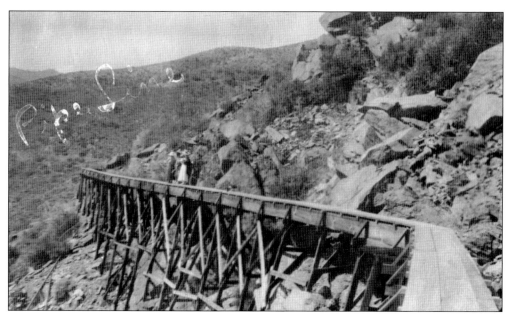
JEROME'S FIRST PIPELINE, C. 1914. A pipeline was constructed to a spring two miles from Jerome. The first pipeline was made of wood. There are currently numerous springs that come out of Mingus Mountain and supply Jerome with water.

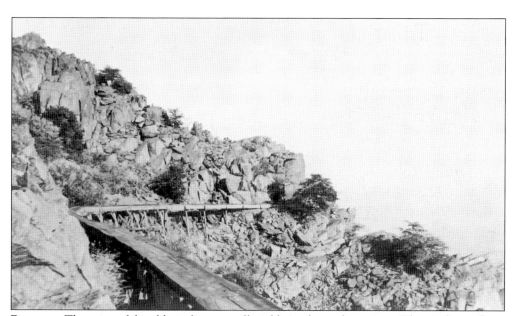
PIPELINE. The ruins of the old pipeline are still visible in places above town. The pipeline reflects the awe-inspiring engineering skills of the town's founders.

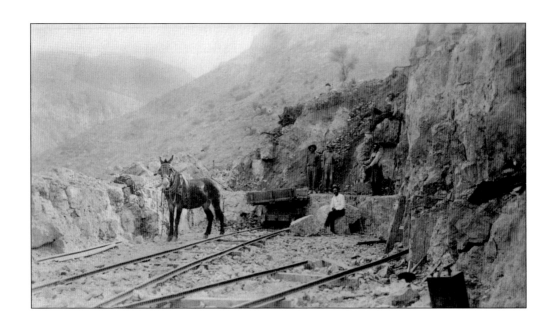

TRANSPORTATION PROBLEM. In the isolated Verde Valley of Arizona, transportation was the main obstacle to mining profits. The billion dollar copper camp label became a reality only after Clark put in roads and the railroad.

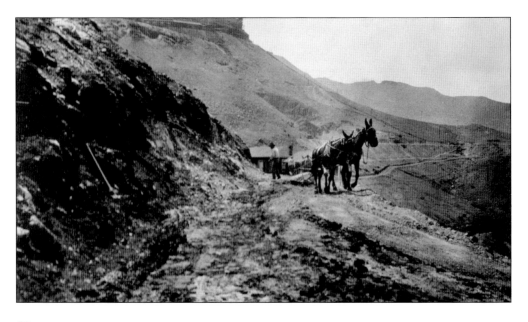

OUTSIDE MINE ENTRANCE. Edith Whitaker and two unidentified men are shown outside of a mine entrance.

AERIAL VIEW OF JEROME, 1928. This good aerial view shows most of Jerome with the UVCC open-pit mine, the Douglas Mansion, and Little Daisy, plus the lower hogback and much of the Gulch area of town. At least one person has noted that a balloon would be better transportation in Jerome than horses and carriages.

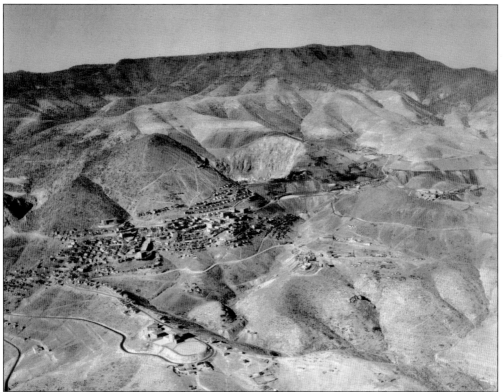

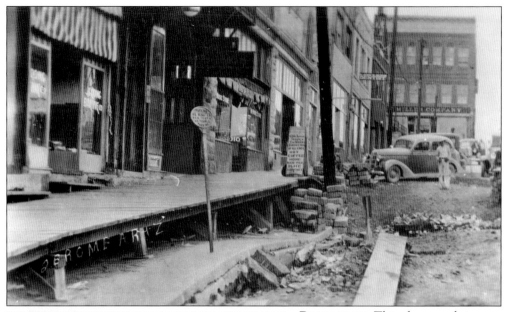

BOARDWALK. This photograph is included for those interested in seeing some of the old road construction with a section of boardwalk outside the Boyd Hotel on Main Street. Unfortunately, in some areas of Jerome it has been discovered that cement was reportedly poured directly over the wooden boardwalks to create sidewalks.

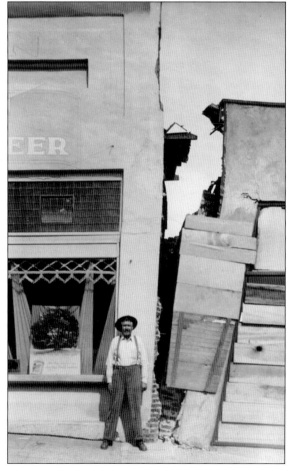

MANMADE EARTHQUAKES. Talk about slides, faults, and blasts! There are reportedly four geological fault lines crisscrossing the Jerome area: the Verde fault, Haynes fault, Hull fault, and Florencia fault. Young states in *They Came to Jerome*, "The Grand Daddy of all mine blasts was exploded in a tunnel 110 feet long. . . . The explosive charge was 260,000 lbs, the equivalent of six standard freight car loads. Windows rattled all the way to Camp Verde!"

LIME YOUR WATER CLOSETS! A notice in the *Jerome News* dated August 4, 1906, reads, "All persons owning outside water closets are hereby ordered to at once use lime in them. If this is attended to at once it will prevent a lot of unnecessary sickness. Lime can be purchased at the T. F. Miller company store. By order of C. W. Woods, City Physician." One can imagine how delightful a mask may be to wear. An awful, pungent sulfur smell permeated Jerome's air in the town's heyday. Apparently the sulfur and smoke would be so thick that it was difficult to breath at times, and they would turn everything gray. There are even "smoke easements" on some property deeds to deal with the sulfur smoke.

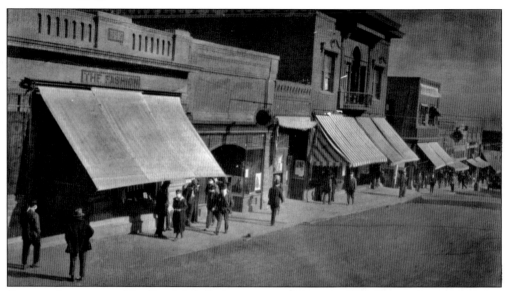

SPANISH INFLUENZA. The Spanish influenza came to Jerome in 1918. It spread at an alarming rate and claimed at least 75 lives in Jerome and 25 in Clarkdale. Public gatherings were forbidden; schools, churches, and theaters were closed. Schools were made into additional hospitals.

64 PROHIBITING EXPECTORATING ON SIDEWALKS

ORDINANCE No. 84

The Mayor and Common Council of the Town of Jerome do Ord
Follows:

Section 1. It shall be unlawful for any person, or persons, t
or expectorate upon any of the public sidewalks, or cross walks, or
the floor, or upon the steps of any public building within the cor
lmits of the Town of Jerome.

Sec. 2. Any person who shall violate the provisions of this
nance, shall be deemed guilty of a misdemeanor, and shall, upon
viction, be fined not less than Five Dollars and not more than F
Dollars, or imprisoned in the Town Jail for not less than five days
more than thirty days.

Passed by the Mayor and Common Council of the Town of Jer
this the 11th day of December, 1917.

Approved Dec. 11, 1917. J. J. Cain,
Attest: Mayor.
 Fred Whitaker, Town Clerk.

JEROME EXPECTORATING ORDINANCE. This ordinance was designed to help protect the health of Jerome residents by prohibiting spitting (expectorating) in public places.

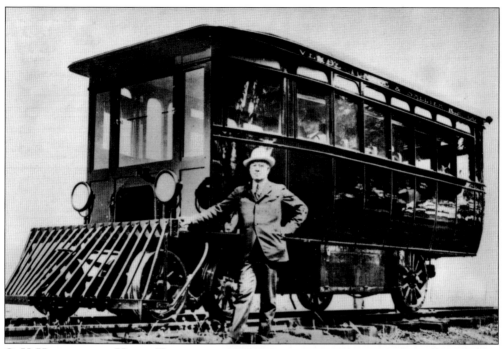

C. V. Hopkins and Verde Tunnel. Engineered by C. V. Hopkins, the Hopewell Tunnel extends from the 1,000-foot level of UVCC to open on a hillside one mile east of the mine. The tunnel is 13 feet wide and 10 feet high and accommodates two tracks for a full standard-gauge train: the Verde Tunnel and Smelter Railroad. From Hopewell, the VT&S railroad runs 6.7 miles to Clarkdale.

Old Smelter and Open-Pit Mine. Clark moved the UVCC smelter to Clarkdale to extinguish the mine fire and have access to the remaining ore. Open-pit mining appeared to be the solution, with high-grade ore remaining above the fire and under the smelter. This photograph shows the old smelter smokestack lying on the mountain into the start of the open-pit mine. This smokestack is still visible today.

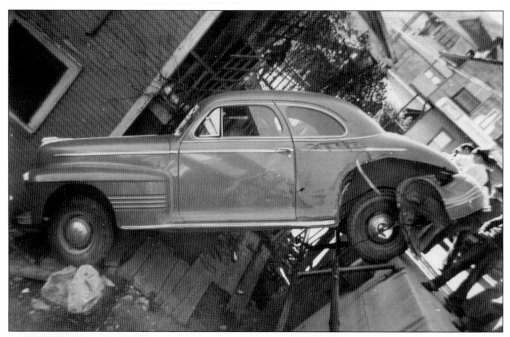

ANOTHER CAR BITES THE DUST, 1940. Somehow this car failed to negotiate the turn on the highway through town. There are actually a number of old rusted shells of antique vehicles in the hills and gulches of Jerome. Cars have been leaving the highway here since the road was first put through to Prescott in 1920.

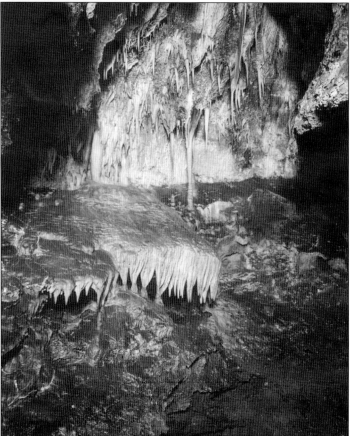

STALACTITES AND STALAGMITES. This photograph was taken from the 2,750-foot level of a local cave. The local mountains have a number of impressive caves.

Five

HEARTS OF SERVICE

Jerome, a ruggedly independent mining community, produced more than copper, gold, and silver. The town also produced or drew many with hearts of service.

During the time of William McKinley's presidency in 1898, fourteen men from Jerome formed Company A of the 1st U.S. Volunteer Cavalry Regiment, the "Rough Riders." These men were commanded by the legendary Capt. William O. ("Bucky") O'Neill of Prescott. O'Neill died during the campaign to take San Juan Hill.

Jerome's Thomas E. Campbell became Arizona's second governor. George W. Hull was one of the original pioneers to arrive in Jerome and owned most of downtown. He served five terms in the house of territorial legislature. He served one term as justice of the peace in Jerome and two years as Jerome mayor.

Frederick Augustus Tritle sold his lease to the United Verde mine to W. A. Clark in 1888 and served as governor of Arizona Territory from February 1882 to October 1885. Clark, owner of the United Verde Copper Company, was a Montana senator from 1901 to 1907.

Lewis William Douglas, the oldest son of "Rawhide" Jimmy Douglas, chose politics as his career. In 1926, he served as Arizona state representative in Washington, D.C., then as director of the budget for Franklin Roosevelt, and in 1947, Pres. Harry Truman appointed him ambassador to the Court of St. James. Douglas taught at Amherst after World War I and then became the only U.S. citizen to be principal of McGill University in Montreal.

Eugene Murray Jerome, the town's namesake, was a nephew of Leonard Jerome, father of Jennie, who became Lady Randolph Churchill and the mother of Sir Winston Churchill.

Rawhide Jimmy Douglas was a major during World War I. He was decorated by the French government in 1927 as a chevalier of the Legion of Honor.

The heart of service is still very present in today's Jerome with the small-town feeling. As a rule, the community looks after each other when there is a time of need. Greg Driver described this to the author well by stating that all of Jerome is a small neighborhood with a strong and necessary sense of community "giveback" in volunteer commitments. Town participation is an essential part of the community.

The J Club is a wonderful service club that consists of past graduates of Jerome High School and others who are enamored with Jerome and have become stewards of the Jerome J above the town on Cleopatra Hill; they take proud responsibility for the care, painting, and lighting of the J—and have fun doing it!

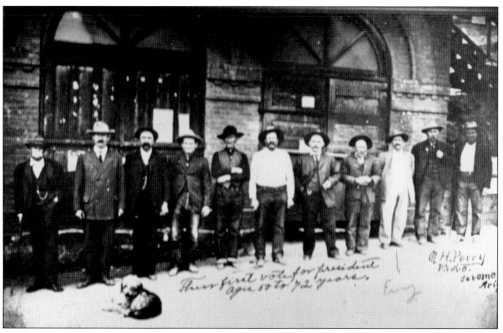

FIRST JEROME VOTE FOR PRESIDENT. The back of this photograph notes that from left to right are George W. Hull, Dan Campbell, James Hubbard, C. M. Grims, J. C. Ray, John Gardiner, Harry Crain, Charles Ewing, and George Brookshir in 1912. They are about to cast their votes.

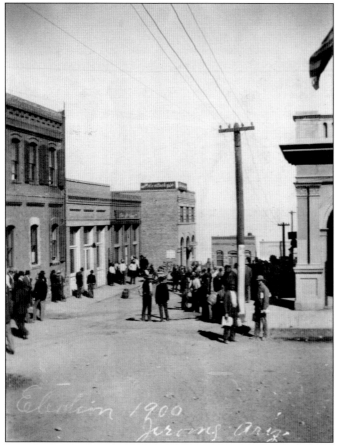

FIRST JEROME TOWN ELECTION, 1900. Jerome was incorporated in 1899 because the growing mining camp desired to put in a water system to provide for fighting fires. There was some disagreement among the founding fathers on whether or not to incorporate. In the end, there was a large turnout for the election.

CRIME PLAYED DOWN. Shown here are Harry Crain (center) and Sheriff Jim Roberts (far right). There were at least five newspapers in Jerome over the years. Reportedly most seemed to follow the lead of playing down crime, at the encouragement of the mine owners, to portray Jerome as a pure and peaceful mining community and a place for quiet family living.

THE ELKS LODGE, 1939. The Jerome Elks Lodge was very active and contributed much to the community.

JOHN L. MUNDS. Munds was an early Jerome deputy sheriff and was elected Yavapai County sheriff in 1898. The son of Jerome mayor William Munds, John reportedly once trailed a killer over 1,400 miles on foot and horseback.

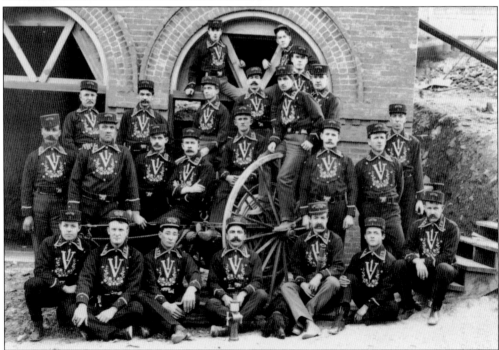

VICTOR HOSE COMPANY, 1901. Jerome had three different hose companies: the Victor Hose Company, Pronto Chemical Hose Company, and the Miller Hose Company.

CORNEL R. H. G. MINTY. Minty posed for this photograph dressed in uniform.

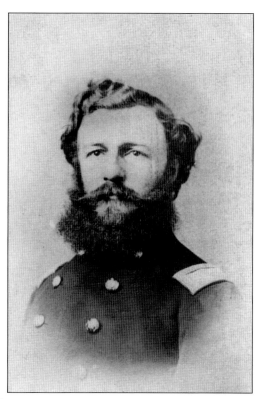

GENERAL MINTY. General Minty was a Civil War hero, distinguished mainly because of his leadership of the Union forces at the Battle of Shelbyville. This photograph is of the general and his granddaughter Glenallen in Jerome.

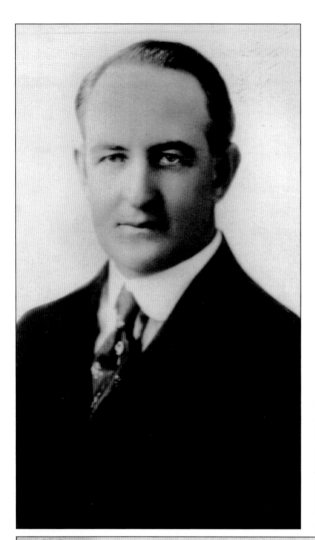

TOM CAMPBELL AND ELECTION CARD. Born Thomas Edward Campbell in 1878 in Prescott, he moved to Jerome in 1899 and was Jerome's first fire chief, then was appointed Jerome's postmaster by President McKinley in 1901. Campbell was elected Arizona's governor in 1916, 1918, and 1920.

"*The office of Governor affords an opportunity for real public service. If I did not believe that, in this office, I could render genuine patriotic service to the people of this State, I would not now be a candidate.*"

—THOS. E. CAMPBELL.

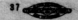

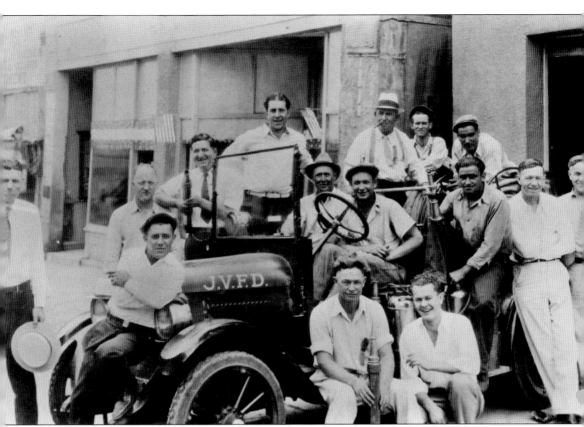

JEROME'S FIRST FIRE TRUCK. The Jerome Volunteer Fire Department was organized in 1899. It is now, and has always been, a community affair. This is a photograph of Jerome's first fire truck (after the days of hose carts), all ready for service, and a few of the proud men who worked with it. Jerome's incorporation in 1899 allowed the community to collect taxes and to raise money to erect water tanks, bury fire lines, construct a fire station, outline a fire district, and adopt one of the first building codes designed to lessen the occurrence of fire; its main provision was to compel construction of stone or brick fireplaces and chimneys and prohibit tents. The pine buildings and canvas tents all contributed to Jerome's fire hazard. Other contributing factors included high winds, alcohol consumption, and a lack of water. One of Jerome's former fire chiefs, Gary Felix, reports an interesting story about an early fire chief—Val Harris was quite the figure in town, wearing twin chrome-plated pistols.

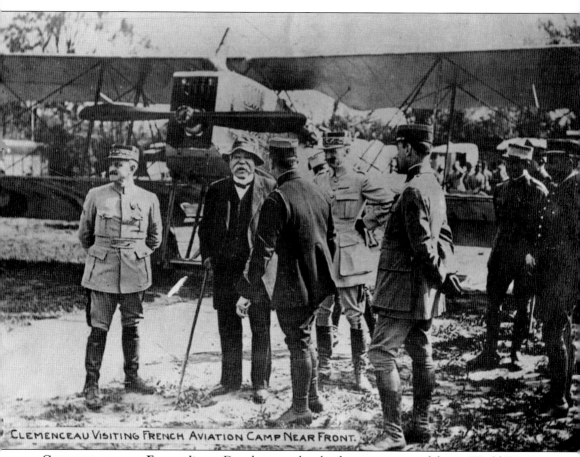

CLEMENCEAU VISITING FRENCH AVIATION CAMP NEAR FRONT.

CLEMENCEAU NEAR FRONT. Jimmy Douglas was taken by the patriotic mood during World War I, where he volunteered and was put in charge of Red Cross stores in France for the entire Western Front. Commissioned a major, he returned home in 1918. Douglas named his smelter town after his good friend Premier Georges Clemenceau of France.

Six

JEROME HISTORICAL SOCIETY AND MINE MUSEUM

On March 15, 1953, the people of Jerome organized the Jerome Historical Society, "dedicated to the preservation of Jerome as a town of vital historical significance to the Verde Valley, to Arizona, and to the West." The mission of the JHS is to protect, preserve, and present the unique physical and cultural history of Jerome through its buildings, architecture, research archives, museum, and other programs for the benefit of residents and current and future generations.

The inspiration for the organization of the JHS and the Mine Museum came from the late Jimmy Brewer, who was curator of the Tuzigoot National Monument. When the mine closed on January 30, 1953, he addressed the city council, saying, "I don't think you people realize what you have here. If you don't do something about it, all you will have left of your town is a pile of rubble." Jerome's slogan, "America's Largest Ghost City," was his idea, and that sign stood on the outskirts of Jerome for many years.

The JHS Mine Museum and Gift Shop was formally dedicated on June 20, 1953. The JHS acquired the building from Verde Exploration in 1957. In 1956, the JHS completed negotiations with Phelps Dodge, ensuring no more buildings would be torn down in the main part of town. The society succeeded in purchasing most of uptown Jerome, thus securing Main Street.

In January 2007, board president Allen Muma and the staff of JHS began a major refurbishment project in the Mine Museum. The museum was designed thematically to illustrate businesses, saloons, brothels, firemen and fire departments, law and order, historical timelines, and other interesting aspects of the town of Jerome. To that end, the JHS has completed a major restoration project on the Boyd Hotel and has recently received a grant to restore the New State Motor Company as well as numerous other smaller projects.

The JHS always welcomes donations of historic photographs, stories, or artifacts that depict the history of Jerome. Located on Main Street, the society is open daily from 9:00 to 5:00 and can be reached at (928) 634-5477.

JAMES BREWER. Brewer was the superintendent of Tuzigoot National Monument at the time Jerome's mines closed. Brewer inspired the formation of the JHS by stating, among a few other things, "You don't know what you are sitting on up there!"

NATIONAL HISTORIC LANDMARK. On April 19, 1967, Secretary of the Interior Stewart L. Udall presented Jerome with the commemorative plaque placed on the stone wall across from the JHS Mine Museum that designates the Jerome Historic District as a Registered National Historic Landmark.

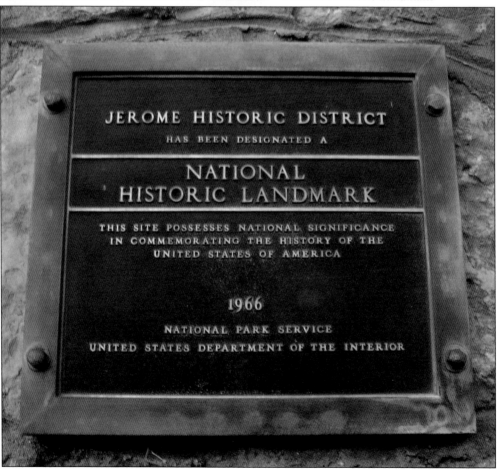

CHRISTINE BARAG, JHS MINE MUSEUM. Christine has been the backbone of the JHS Mine Museum for the past 16 years. She has extensive family roots in Jerome and a wealth of Jerome stories to share. Her great-grandfather Carlos Armijo Gallegos, a miner, is pictured in the early 1900s in one of the displays inside the Mine Museum. Her grandmother, Enriqueta Madrid, worked inside the JHS Mine Museum when the building was a dime store. Be sure to visit the Mine Museum; visitors may enjoy asking Christine some of the Jerome mining stories she knows as well as one story about Elvis and the pork chop.

JHS STAFF. The JHS staff is pictured in 2008; from left to right are Annie Mae Kelly, Jay Kinsella, Ronne Roope, and Shirley R. Pogany. The half wheels in front and at the side of the Mine Museum are halves of the flywheel from the air compressor at Phelps Dodge (United Verde) mine. The bell outside the Mine Museum was cast in Cincinnati, Ohio, with the inscription "Town of Jerome, February 1904" and was installed in the belfry of the old Jerome Town Hall.

CLARK STREET. Marci Sleep stands by the Clark Street town limits sign in the 1940s. The sign reads, "Jerome, Mile High with a 50-mile view." You can actually see much farther than 50 miles, with views all the way to Flagstaff and beyond.

ENTERING JEROME. This photograph was taken in 1941 of Jerome's city limits entering from the southwest.

HAMPSHIRE AVENUE MILITARY. Erma Sleep is pictured by the military area on Hampshire Avenue (Lower Hogback). Readers are asked to contribute any information they may have on this sign.

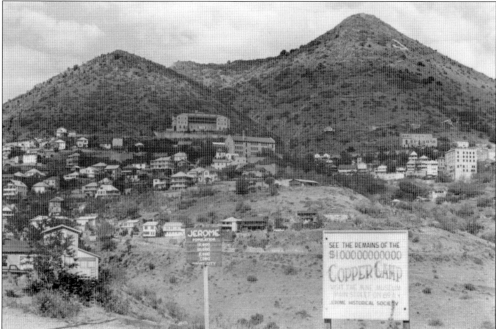

GHOST CITY. These signs are now gone but well remembered. These were located in what is now the Jerome Historic Overlook on Hampshire Avenue (Lower Hogback). Many of Jerome's houses were moved away from Jerome when the mines closed—some were even reportedly cut in half and moved to Flagstaff.

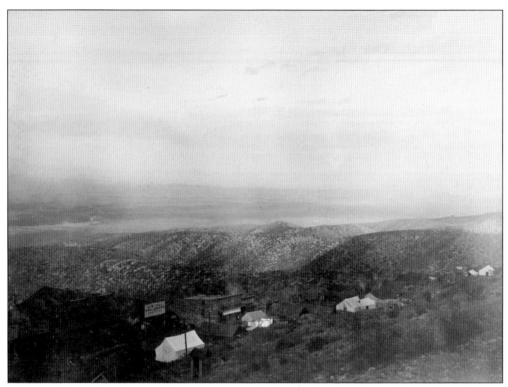

JEROME, 1880. This photograph captures an early view of Jerome with the Hull store and tents. Paul Hull, editor of the *Arizona Graphic* in Phoenix, stated in 1899, "Jerome, one of the earth's richest treasure houses." Jerome was mostly a tent town in the 1880s.

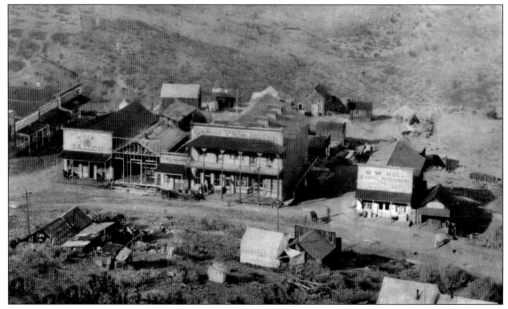

JEROME MINING CAMP, 1896. This photograph of the Jerome business district was taken 20 years after the first recorded claim and three years before incorporating as a town after suffering tremendous fire damage.

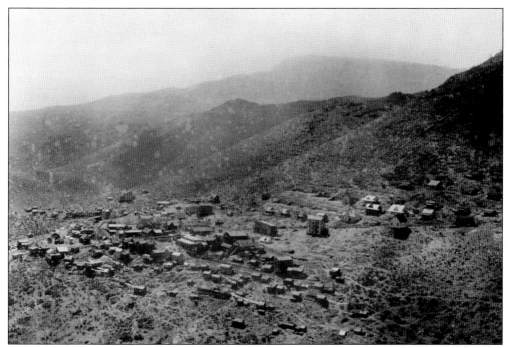

JEROME PANORAMA, 1898. This early panorama was taken from Sunshine Hill. Sunshine Hill was reportedly given its name because it is the last area of town to receive the sun's rays as it goes down in the west.

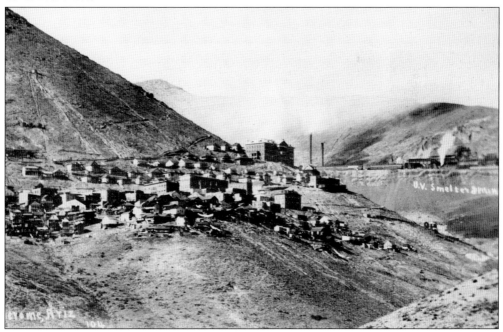

JEROME, 1900. This photograph shows early Jerome with the massive Montana Hotel and the United Verde smelter in 1900, prior to Clark moving the smelter to Clarkdale. An article in the February 5, 1903, *New York Sun* newspaper reads, "This Jerome is a bad one—the Arizona copper camp now the wickedest town."

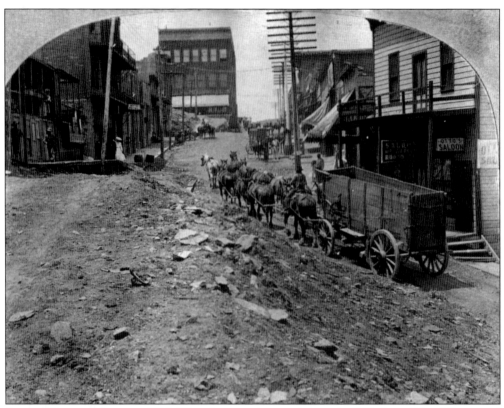

STREET SCENE IN JEROME, 1902. This photograph was taken at the "V" where School Street and Main Street separate. Note the still standing and wonderfully restored Boyd Hotel on the left.

SCHOOL AND MAIN STREETS. There have been underground passages found in some of the old dwellings and businesses, linking various locations underground.

SULLIVAN HOTEL. This is a rare archive photograph of the Sullivan Hotel with her gas pump outside. The Connor Hotel is the brick building past the Sullivan on the left. Currently there are no gas stations in Jerome. Those who need gas have to coast down to the bottom of the mountain toward Clarkdale to fill up—fortunately right at the first stop sign.

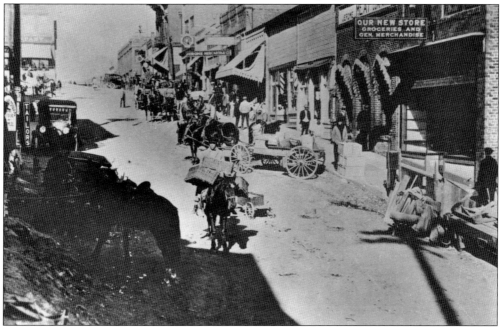

THRIVING BUSINESS DISTRICT. This scene is of a busy downtown with a mixture of horses, mules, carriages, cars, wagons, and buildings with signs and awnings to capture your business and outfit your camp. Horses, mules, and burros were used in hauling and construction around the mine and smelters until about 1920, when they were replaced by motorized equipment.

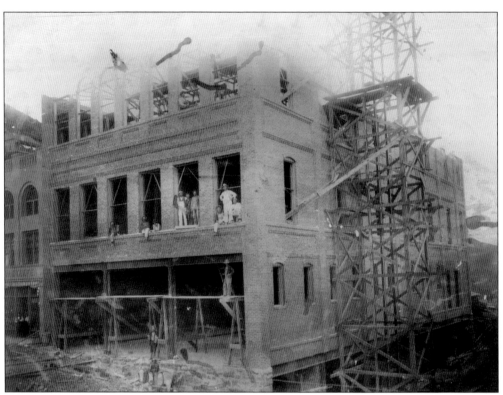

BUILDING THE T. F. MILLER COMPANY STORE, 1898. The T. F. Miller building dominated the Jerome business district from 1899 to 1953. It was built of native sandstone and brick. The first floor held Jerome's first bank, the Bank of Arizona, the post office, a jewelry store, and a barbershop with baths. The second floor was for the T. F. Miller business. The third floor held an 800-seat stage and opera house. The fourth floor held rooms for lodge meetings, a billiards room, reading room, library, banquet room, and kitchen.

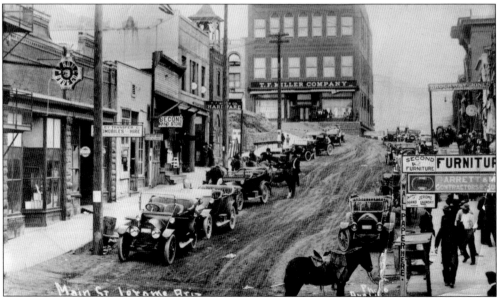

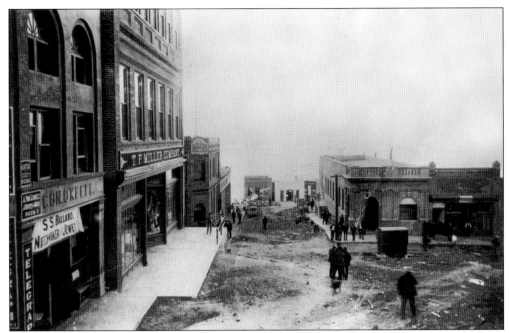

JEROME AVENUE AND MAIN STREET, 1910. To stand where this photograph was taken, one would walk up the stairway across from the Connor Hotel and next to Town Park and then look back. The Connor Hotel will be still standing on the left and the JHS Mine Museum on the right.

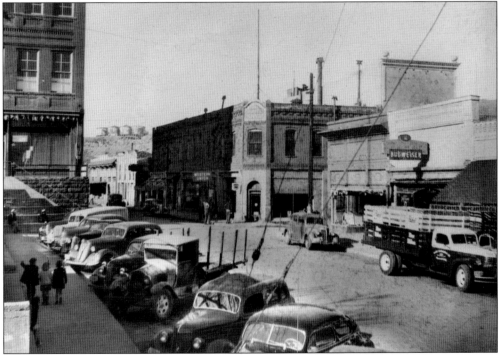

"TENDERLOIN DISTRICT." The cribs area of old Jerome was located on Main Street just north of the Connor Hotel and was referred to as the Tenderloin District. This would be the area located behind the Connor Hotel in this photograph.

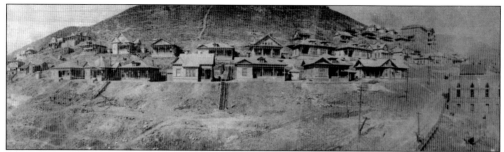

COMPANY HILL, 1913. Also known as Cleopatra Hill, Company Hill was the main housing area for the UVCC mine in 1913. The Montana Hotel was built to house the UVCC miners and the company houses for the executives of the mine. "High society" had to do with how high up on the mountain a house was located; the higher a person was, the more status he had. There used to be a row of houses with a white line painted horizontally across the houses to denote the mile-high elevation of 5,280 feet on Giroux Street.

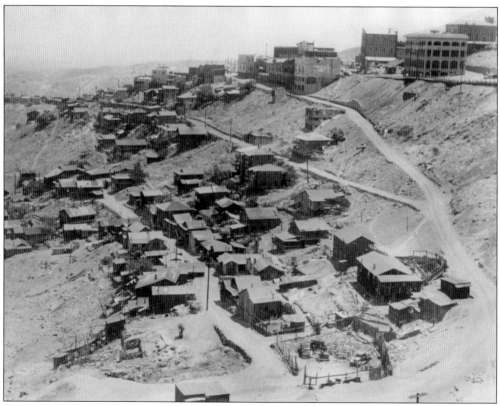

"FOREIGN QUARTER" OR "MEXICAN TOWN." This is an early view of housing below Jerome's business district. Today there are only a handful of these buildings remaining, though many of the ruins remain strewn about the ground.

GULCH, 1912. The Gulch was a thriving area of town in 1912, with two general stores, a dance hall, an elementary school, and a smelter. Jerome was covered with pine, oak, and manzanita trees in the late 1880s. After the trees were gone (see photograph below), Jerome had a tremendous erosion problem and was seeded with ailanthus (or paradise) trees on Cleopatra Hill in 1964.

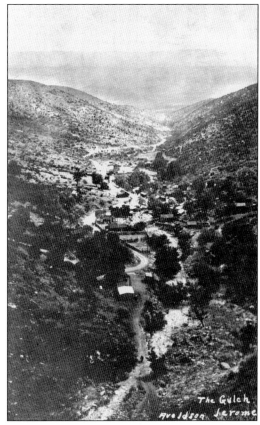

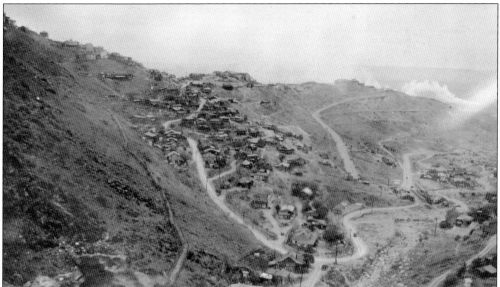

GULCH, 1941. This relatively late photograph of the Gulch shows the complete absence of trees in Jerome at the time. The trees had all been either harvested for building, burned, or prevented from growing by the reportedly high sulfur content in the soil deposited from the mines. In 1917, a reported 60 homes were destroyed by fire in the Gulch.

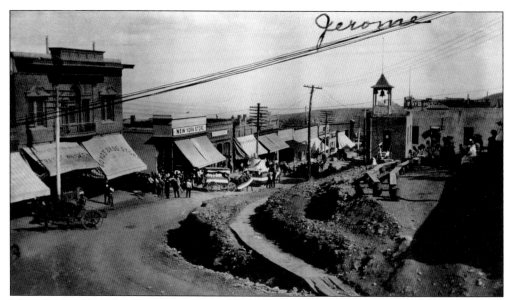

MAIN STREET BUSINESS DISTRICT. This is a photograph of early Main Street with the Bartlett Hotel across from the start of Town Park. Town Park has always been a focal point for Jerome gatherings. Here the boardwalk and bench seating are set up for a possible Fourth of July parade gathering.

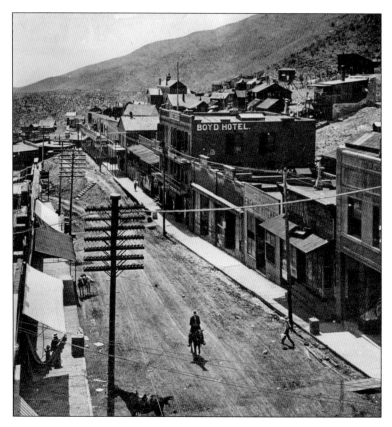

MAIN STREET BUSINESS DISTRICT, 1906. This dramatic photograph captures a quiet moment with a single rider on Main Street in Jerome in 1906.

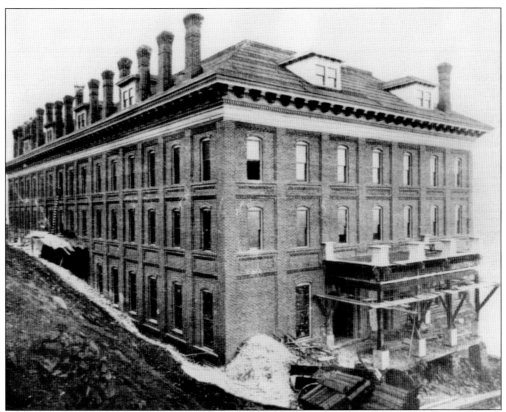

BUILDING THE MONTANA HOTEL, 1899. This is a rear view shot of the Montana Hotel being built. The Montana had 200 rooms, a dining room that seated 400 people, 45 marble washstands, a barbershop, and cigar stand. The architect was F. H. Perkins of Phoenix.

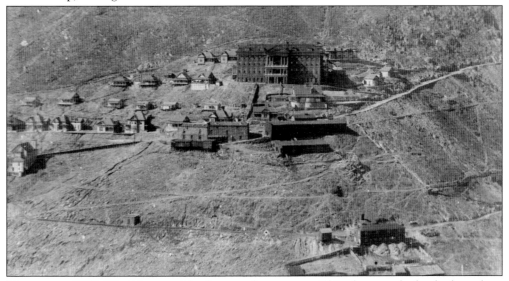

MONTANA, 1915. The Montana Hotel towered over town. This photograph clearly shows how stately the Montana Hotel was. The Montana was a great tribute to the heart and compassion of W. A. Clark, as he built the hotel for the comfort of his miners.

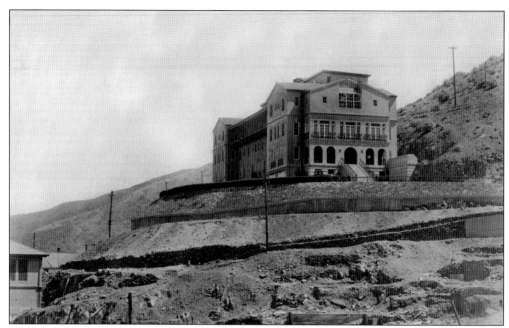

THE FOURTH HOSPITAL. Jerome's fourth hospital is now recognized as the current Grand Hotel and Asylum Restaurant.

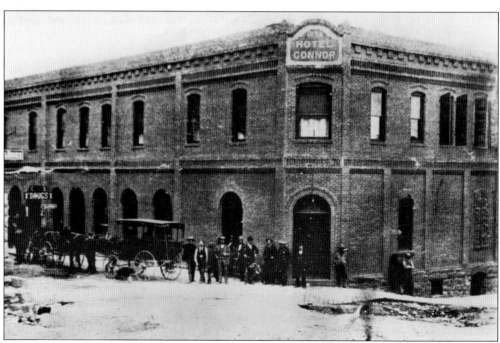

THE CONNOR HOTEL. The Connor Hotel was built of brick after the ordinance was made that no business district buildings could be made of wood or canvas. This ordinance was passed after Jerome suffered many devastating fires between 1894 and 1899. There was another fire that gutted the wooden interior of the Connor Hotel, though it left the walls standing to be rebuilt. Note the arched windows on the first floor in the original construction.

POWDER BOX CHURCH. The Powder Box Church got its name because it was reportedly built from the wood of discarded dynamite boxes. It has been restored as a beautiful private home now—and was even finally given a cement foundation in 2007, after standing all these years on a foundation of random stones.

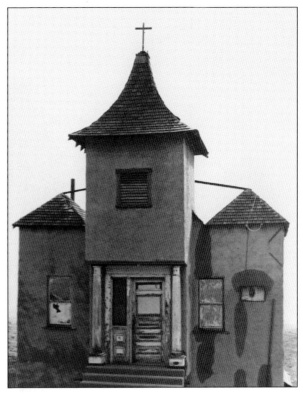

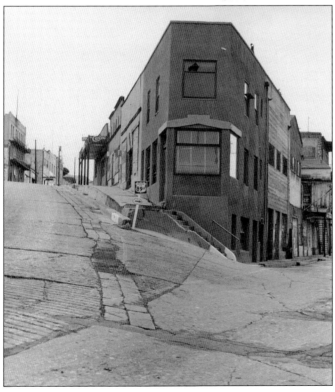

FLATIRON BUILDING. There is a story told about Admiral Byrd and his penguins. Apparently Byrd returned with more than one penguin; one penguin went to the Smithsonian and one went to Jerome! The Jerome penguin had an eventful stay here and was eventually stolen from one of the downtown shops years ago. The building in this photograph is currently the popular Flatiron Café.

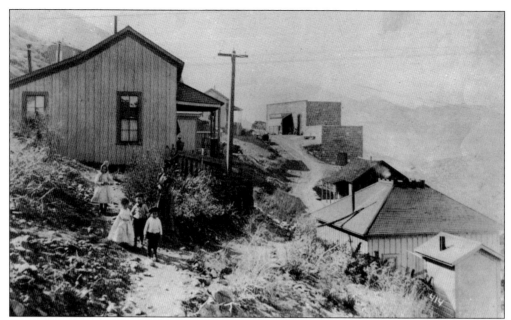

OLD WAREHOUSE, 1896. The sandstone building on the far right is the original T. F. Miller Company Store warehouse building and the oldest building still standing in Jerome. It is now a lovingly restored private residence.

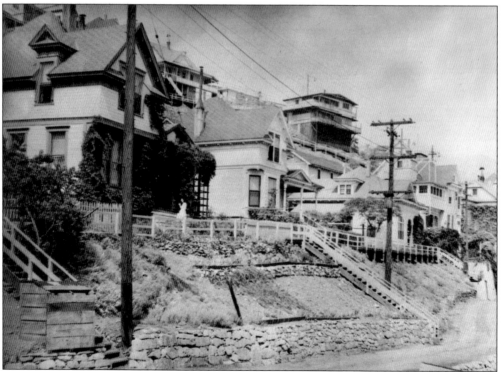

MAGNOLIA AVENUE DWELLINGS. This is a photograph of a few of the Magnolia Avenue dwellings located on Company Hill. There are a few of these elegant buildings still standing. Magnolia Avenue was reportedly named after the magnolia trees planted there.

STILLS IN THE HILLS. There were several stills set up in various homes and gulches around Jerome, including a cleverly concealed one below this author's basement closet.

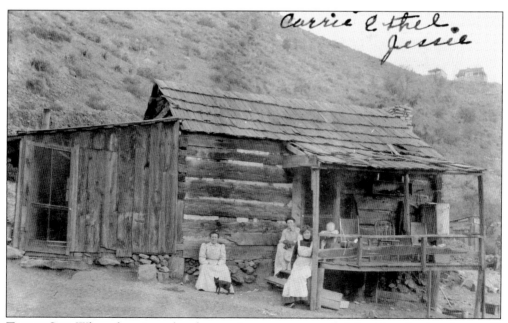

TABLES SET. When the mines closed, many Jerome townspeople left with only what they could carry. Years later, their homes were opened to find them fully furnished; frequently the table was set and ready for them to return.

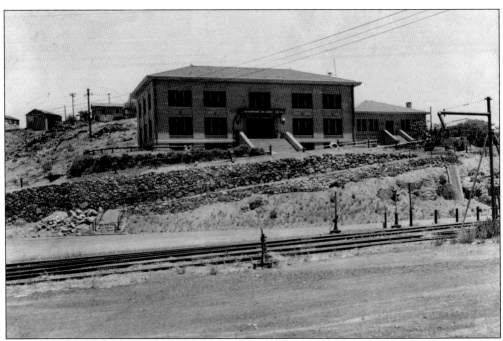

PHELPS DODGE BUILDING. This view of the Phelps Dodge building on Sunshine Hill shows the railroad tracks still in the foreground. This area has now become a parking lot.

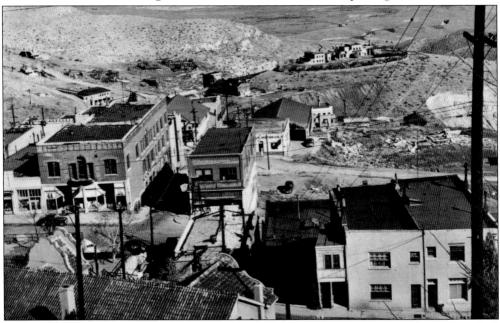

A SOMEWHAT ACCURATE LIST. The charming Jerome phone book is a "somewhat accurate list" of local phone numbers that is privately published compliments of the Raku Gallery. Donations for the phone book's seventh edition are given to the town library to buy a piece of equipment for public use. This view was taken from above the Episcopal church (now the JHS offices) on Cleopatra Hill. The buildings on the lower right are now the Haunted Hamburger Restaurant and Twin Star Grocery (formerly a telephone company).

Seven

JEROME STATE HISTORIC PARK

The large, impressive white building in the lower part of town is the former home of James S. Douglas—"Rawhide" Jimmy Douglas, the Crown Prince of Copper. The historic Douglas mansion above the UVX mine site was presented to the State of Arizona by the Douglas sons as a memorial to their father and is listed on the National Register of Historic Places. Today it is the Jerome State Historic Park.

Douglas reportedly had the mansion designed as a home for his family as well as a place for visiting investors and mining officials. It was built in 1916 of adobe bricks made on-site. Jimmy's mansion had many luxuries: marble shower, steam heat, wine cellar, billiards room, and a central vacuum system.

James S. Douglas and associates acquired the United Verde Extension Gold, Silver, and Mining Company, located in Jerome, in 1911. In December 1914, drills went through into a bonanza of ore. Since then, the mine has produced $150 million in copper, gold, and silver. Douglas renamed the United Verde Extension the Little Daisy Mine—it would become one of the richest mines in the world. In the 23 years of Little Daisy production, the mine yielded 397,000 tons of copper, 221 tons of silver, and 5.25 tons of gold.

Douglas was born at Harvey Hill mine in Megantic Township, Quebec, Canada, in 1868 and came to Arizona with his father, Dr. James A. Douglas, founder and developer of the Copper Queen mining district of Bisbee, Arizona.

The museum is devoted to the history of Jerome and the Douglas family. It exhibits photographs, artifacts, minerals, a video presentation, and a not-to-be-missed 3-D model of the town with its underground tunnels and shafts. The museum, located on Douglas Road just off Scenic Highway 89A, is open daily from 8:30 to 5:00 (closed on Christmas) and can be reached at (928) 634-5381.

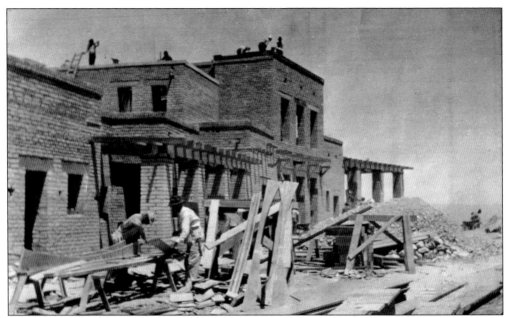

DOUGLAS MANSION. The Douglas Mansion was built from adobe blocks made on-site. Douglas's heirs donated the Douglas Mansion and grounds to the Arizona State Parks System as a memorial to their father in 1962.

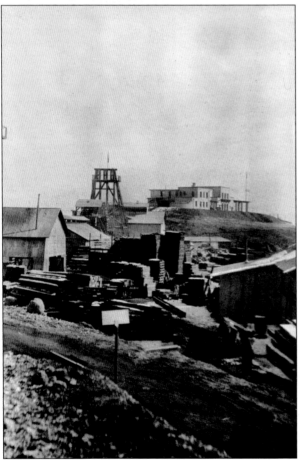

DOUGLAS MANSION, 1916. This photograph shows the Douglas Mansion right after it was completed in 1916 and the bonanza Little Daisy (UVX) mine just below and in front of it. This headframe had a reported $100 million worth of copper ores hoisted from it. Douglas felt it was important to build his main residence where his mine was located.

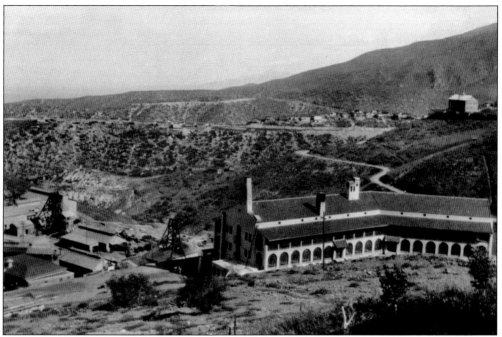

THE LITTLE DAISY HOTEL. The Little Daisy Hotel was built by Rawhide Jimmy Douglas to house his miners for the Little Daisy mine. UVX is on the left in this photograph, the Hogback area of Jerome is in the background, and the old Jerome grammar school is on the upper right. The roof of the Little Daisy Hotel was taken for salvage after the mine closed. The Little Daisy Hotel is now a beautifully restored private residence.

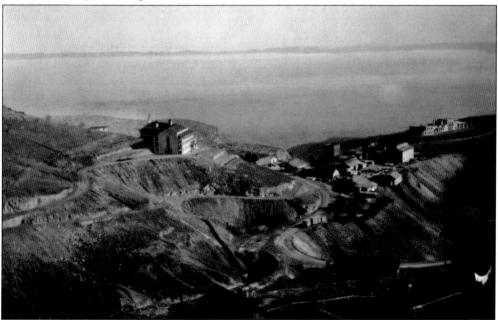

UVX AREA. This photograph shows the Douglas area of Jerome with the Little Daisy Hotel, mine, and Douglas Mansion. There are a number of Douglas's executive homes past the hotel on the left. Sedona and Flagstaff are viewed in the distance.

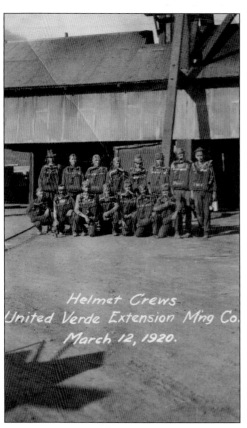

UVX Helmet Crews. UVX helmet crews pause for a photograph on March 12, 1920.

Hardworking Crew. This photograph is of some of the Little Daisy mine crew on the steps outside the main office.

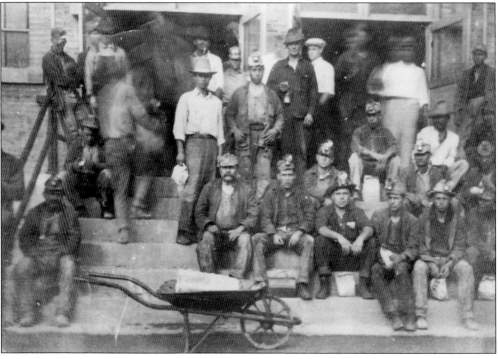

BIBLIOGRAPHY

Brewer, James W. Jr. *Jerome: Story of Mines, Men, and Money.* Tucson, AZ: Southwest Parks and Monuments Association, 1993.
Jerome Community Service Organization. *Jerome Tourguide.* Jerome, AZ: Haven Methodist Church, 1994(?).
Jerome Historical Society. *The Jerome Chronicle.*
Rodda, Jeanette, and Nancy R. Smith. *Experience Jerome, The Mogules, Miners and Mistresses of Cleopatra Hill.* Sedona, AZ: Thorne Enterprises, Inc., 1990.
Wahmann, Russell. *Auto Road Log.* Cottonwood, AZ: Starlight Publishing, 1982.
———. *Narrow Gauge to Jerome, The United Verde and Pacific Railway.* Jerome, AZ: Jerome Historical Society, 1983.
Young, Herbert V. *Ghosts of Cleopatra Hill, Men and Legends of Old Jerome.* Jerome, AZ: Jerome Historical Society, 1964.
———. *They Came To Jerome, The Billion Dollar Copper Camp.* Jerome, AZ: Jerome Historical Society, 1972.

Discover Thousands of Local History Books Featuring Millions of Vintage Images

Arcadia Publishing, the leading local history publisher in the United States, is committed to making history accessible and meaningful through publishing books that celebrate and preserve the heritage of America's people and places.

Find more books like this at
www.arcadiapublishing.com

Search for your hometown history, your old stomping grounds, and even your favorite sports team.

Consistent with our mission to preserve history on a local level, this book was printed in South Carolina on American-made paper and manufactured entirely in the United States. Products carrying the accredited Forest Stewardship Council (FSC) label are printed on 100 percent FSC-certified paper.